IMAGES
of America

# CONNECTICUT AND RHODE ISLAND COVERED BRIDGES

Roger,
  Thank you for supporting
historic covered bridge
research
        Bill Caswell
        March 3, 2012

IMAGES
*of America*

# CONNECTICUT AND RHODE ISLAND COVERED BRIDGES

William S. Caswell Jr.

ARCADIA
PUBLISHING

Published by Arcadia Publishing
Charleston, South Carolina

Printed in the United States of America

Library of Congress Control Number: 2010942627

For all general information, please contact Arcadia Publishing:
Telephone 843-853-2070
Fax 843-853-0044
E-mail sales@arcadiapublishing.com
For customer service and orders:
Toll-Free 1-888-313-2665

Visit us on the Internet at www.arcadiapublishing.com

*To my parents, Shirley Farrell and William Caswell; grandmother, Jessie Mason; and in memory of my grandmother, Evelyn Caswell, who passed away during this book's preparation*

# CONTENTS

# ACKNOWLEDGMENTS

First and foremost, I wish to thank my wife, Jennifer, for supporting every project I undertake, for cheerfully spending our days off from work visiting libraries and historical societies, and for helping with the layout and proofreading of this book.

Special thanks to Richard Roy, a well-respected authority on covered bridges for over 50 years, for sharing his knowledge and his remarkable collection of covered bridge photographs, postcards, books, and other memorabilia. His generosity and eagerness to help have been a continuous source of inspiration over the years.

Thanks also to David Wright and Joseph Conwill of the National Society for the Preservation of Covered Bridges (NSPCB) for providing access to the society's collections.

Others helping along the way include Laura Katz Smith and the staff of the Thomas J. Dodd Research Center at the University of Connecticut; Charlie Dunn, New Haven Railroad Historical and Technical Association; Clifford Alderman, Unionville Museum; Todd Clark; Christos Xenophontos and Michael Hébert, Rhode Island Department of Transportation; Peg Giles, F.H. DeMars Images (www.demarsimages.com); Andy Rebman; Christina Keyser Vida and the staff of the Windsor Historical Society; Catherine T. Wood, Norman B. Leventhal Map Center at the Boston Public Library; Leslie Page and Barbara Bussart, Woonsocket Harris Public Library; Dr. Lawrence Carlton and the staff of the Canton Historical Museum; Robert Grigg, Colebrook town historian; Elizabeth Malloy, Haddam Historical Society; Paul Hart, Barkhamsted Historical Society; Max Miller; Joseph Pepe, Miller Memorial Central Library, Hamden; Dianne Brown and William Shannon, Norwich Historical Society; Edward J. Ozog; Brian McKee; Bob and Trish Kane; Nora Howard, Avon town historian; Marian O'Keefe, Seymour Historical Society; Michael A Krenesky, selectman, Beacon Falls; Jamie Eves, Windham town historian; Beverly Historical Society; Nancy Finlay, Connecticut Historical Society; LJ Place; and Lysa Bennet Crouch.

Finally, thank you to my editors, Hilary Zusman and Lissie Cain, and Arcadia Publishing for providing this opportunity to share my research with all of you; my parents and grandparents for encouraging my interest in history at a young age; and our children, Stephen, Sarah, Benjamin, Jacquelynn, and Rebecca, for tolerating visits to covered bridges on every family vacation.

# INTRODUCTION

My ability to prepare this publication is a direct result of the success of *Covered Spans of Yesteryear* (www.lostbridges.org), a volunteer project documenting the former covered bridges of the United States and Canada, cofounded by Bob and Trish Kane, Richard Roy, Bill Cockrell, and myself in April 2003. With the generous help of Todd Clark, Thomas Kipphorn, Miriam Wood, historians from the various covered bridge societies, and dozens of others, over 13,000 wood truss bridges have been documented.

Covered bridges once dotted the landscape of Connecticut and Rhode Island. From the hills of Canaan, Connecticut's northwestern-most town, to Narragansett in southeastern Rhode Island, over 150 covered bridges were known to have existed within the region. Over the past century and a half, flood, fire, old age, and progress have claimed all but three of these historical structures. Nearly two-thirds of the bridges were in the western part of Connecticut. Most of Rhode Island's covered bridges served the railroads in the northern part of the state. They primarily served the industrial areas of the state with the heaviest concentration in the city of Woonsocket.

The earliest covered bridge in Rhode Island was the Washington Bridge over the Seekonk River connecting Providence and East Providence, Rhode Island, at India Point, which replaced an open wooden bridge that was built in 1793. The 1793 Washington Bridge, named after President Washington, was destroyed during the Great September Gale of 1815 when a wind-driven storm surge sent lumber schooners and fishing ships crashing into the bridge. While a replacement was built in 1815, the covered bridge that we are familiar with was probably constructed later. A statement in *An Historical Sketch of the Town of East Providence* (1876) indicates that well-known architect James C. Bucklin rebuilt the woodwork of the Washington Bridge in 1829. This fits well with a statement Ithiel Town made in an 1831 paper promoting improvements to his truss design. In his introduction, Town listed a number of significant bridges constructed using his plan within the past 10 years, including one at Providence. Since the railroad bridge wasn't built until 1835, he may have been referring to the 1829 Washington Bridge, which was constructed with a Town lattice truss. The Washington Bridge was damaged during a storm in 1867. At the time of that storm, plans had already been underway to widen the draw span at the east end of the bridge. The bridge was closed while repairs and improvements were made.

In 1816, the Norwich & Preston Bridge Company was incorporated to construct a crossing of the Shetucket River between Norwich and Preston. They contracted with Capt. John Winthrop of Windham, Connecticut, to build Connecticut's first documented covered bridge about half a mile upstream from the river's mouth. It included two stone abutments and two stone piers costing $10,000 to construct. The freshet of March 6, 1823, lifted the bridge off its supports and carried it downstream until it broke up on the falls near where the Shetucket empties into the Thames River. A new bridge was immediately built at a cost of $5,000. The Towns of Norwich and Preston purchased the succeeding bridge in 1858 and abolished tolls.

The first Preston Toll Bridge was one of many to have been destroyed by floods over the years. The early floods have probably claimed several other covered crossings that have yet to be documented. Newspaper articles at the time of the Connecticut River flooding in May 1854 described it as the greatest ever recorded, surpassing the Jefferson Flood of 1801. At Hartford, the river was 29.5 feet above the low-water level, two feet and six inches above the 1801 flood stage. Many bridges were destroyed during that torrent when floodwaters caused the failure of the Gaylordsville Dam. Four of the bridges lost were known to have been covered bridges: the Farmington River crossing at Windsor and three structures over the Housatonic River in New Milford.

Other major floods in 1869, 1891, 1896, and 1936, along with a few less significant ones, claimed more covered bridges. On August 13, 1955, Hurricane Connie dropped four to six inches of rain. Five days later, another hurricane, Diane, dropped an additional 9 to 14 inches of rain in a 30-hour period between Thursday morning and Friday afternoon. By August 19, rivers were raging in both states, from the Farmington River in Western Connecticut to the Blackstone River in Northern Rhode Island. In Woonsocket, the roaring Blackstone River destroyed the Hamlet Railroad Bridge, Rhode Island's last historical covered bridge. At the same time, the Farmington River experienced one of its worst floods. The destruction included steel bridges that were built to replace earlier covered spans.

On the railroads, sparks and embers from steam-powered engines were dangerous to wooden bridges. Some railroads were known to have bridges checked after the trains crossed to make sure no smoldering embers were left behind. Since many of the railroad structures were in remote locations, the fires often went unnoticed until it was too late to save the bridge. Some examples, such as the 1935 fire on Bandwagon Bridge in Woonsocket, Rhode Island, were significant local events. The general alarm fire caused damage estimated at $75,000. The blaze threatened the Crown Piece Dye Works, and then flames were pushed across the river by high winds to level a large warehouse of the Bouvier Construction Co. A heat explosion damaged the adjoining two-story brick building on Sayles Street occupied by the Verhulst Combing Company. A temporary wooden bridge built after the fire was replaced by a new steel span in September 1941.

The Boston & Providence Railroad's bridge over the Blackstone River between Pawtucket and Central Falls, Rhode Island, was a deck-type structure where the supporting truss work was underneath the rails. To reduce the risk of fire, a layer of metal sheathing was placed under the tracks to keep sparks from the engine from landing directly on the wooden structure. Because of this, it became known as the Tin Bridge. Later iron and steel bridges are still known by this name.

The most spectacular bridge fire in the area was probably the burning of the Hartford Toll Bridge in 1895. The *Hartford Courant* estimated that over 20,000 people lined the streets to watch the conflagration.

Today's covered bridges have a nostalgic appeal about them, reminding visitors of a simpler time and slower pace of life. That wasn't always the case. In the 19th century, covered bridges were a ubiquitous part of the landscape, and the local citizen's opinion of them was markedly different. These were the days when much of the traffic was still powered by horses. Towns were often eager to replace their smelly, old, creaking wooden bridge with a nice, new, open, iron or steel structure. Take, for example, this excerpt from the *Naugatuck Daily News* of May 19, 1900, discussing the bridge at Beacon Falls: "Until such time as that old covered bridge is torn down it would be a good idea to do a little cleaning up there occasionally. The smell that arises from waste matter on the bridge is not pleasant, to say the least, and a person crossing the bridge feels better after he gets into the open air."

The next week's paper thanked those who took the writer's advice and cleaned up the bridge. That token of appreciation was short lived. The June 9 edition stated, "The stench that arose from waste matter here Friday was enough to make a person feel sick. Why not take off the cover, or better still, build a new bridge without a cover. A new iron bridge in place of that old covered bridge would be an ornament to the town that would be worth all it would cost."

The covered bridge at Beacon Falls remained in place for 35 more years.

Although not widely known for its covered bridges, Connecticut's bridge builders have certainly left their legacy. One of the earlier (and less well-known) builders was Jonathan Walcott. Walcott was born in Windham in 1776 and died there at age 43 on November 13, 1819. He is credited with building the open wooden bridge that preceded the covered toll bridge over the Connecticut River and connecting Hartford and East Hartford. In 1812, he traveled to Columbia, Pennsylvania, where he submitted a proposal for construction of a bridge over the Susquehanna River connecting Columbia with Wrightsville. His proposal for $20 a foot was selected, and construction began in 1812. Henry and Samuel Slaymaker built the masonry for the 28-span structure that stood 27 feet above the water. Walcott's bridge was 30 feet wide to provide two lanes of travel and covered a distance of 5,690 feet at a total cost of $231,771. When completed on December 5, 1814, it was the longest covered bridge ever built and still holds that record to this day. On February 3 and 4 in 1832, five spans were destroyed by ice. The entire bridge was eventually swept away. A new covered bridge built in 1834 to replace it was burned during the Civil War.

The Columbia-Wrightsville Bridge was built using a truss design patented by Theodore Burr. Burr was born on August 16, 1772, in Torrington, located in the northwestern part of Connecticut. In 1792 or 1793, he settled in Oxford, New York. His home is now the Oxford Memorial Library, the last remaining structure built by Burr. In 1804, Burr constructed an 800-foot-long bridge over New York's Hudson River between Waterford and Lansingburgh. He patented the truss design (now known as the Burr truss) of this structure. The Waterford-Lansingburgh Bridge was covered in 1814 and remained in service until a fire destroyed it on July 10, 1909. Burr's arch truss was only used in a few Connecticut bridges, such as the one at Satan's Kingdom and the Hartford Toll Bridge that replaced Walcott's open wooden bridge over the Connecticut River. Other early bridges, such as the Preston Toll Bridge in Norwich and Birmingham Bridge between Derby and Shelton, were probably Burr trusses too. No Rhode Island covered bridges are known to have been built with Burr trusses. While not very popular in these two states, Burr's arch design was used extensively throughout much of the country. Today, Burr trusses support about a quarter of the remaining covered bridges.

The Hartford Toll Bridge was built in 1818 by Ithiel Town and Isaac Damon. Town was born October 3, 1784, in Thompson, which is located in the northeast corner of Connecticut. After constructing the Hartford Toll Bridge, Town went south to construct a number of bridges in North and South Carolina. It was during this time that he developed a new truss design to meet the need for a structure that was lighter and simpler to build than the designs in use at that time. His Town lattice truss was patented in 1820. It contained a series of crisscrossed beams held together by wooden pegs called trunnels. Supporters of this simplified method of bridge construction reportedly described the trusses as capable of being "built by the mile and cut off by the yard." Town didn't actually construct many bridges, though he earned a steady income by charging builders a royalty for using his design as holder of the patent. In an 1839 document, Town stated his fees as "one dollar per foot, for the length of the bridge, if applied for and paid before commencing; otherwise, two dollars per foot will be charged, as indemnity for the risk of bad construction, when erected without proper directions and authority, by which great injury is generally done to both parties." Town's initial design was improved and patented again in 1835. Like the Burr truss, about a quarter of the existing covered bridges use the Town lattice design.

The development of the Town lattice truss was only one of his many contributions to architecture. In addition to his bridge design, Town was a prominent citizen in New Haven, where his architectural work can still be seen around the city in buildings like the Trinity Church and Center Church on the New Haven Green and Yale University's International School of Finance and School of Management.

Between 1829 and 1835, Town partnered with Alexander Jackson Davis in one of the first professional architectural firms in the United States. Their works included the state capitol in New Haven, Christ Church Cathedral and Wadsworth Athenaeum in Hartford, the capitol buildings of Indiana (1831–1840, demolished in 1877) and North Carolina, and the US Custom House, now Federal Hall, in New York City.

In 1839, Town commissioned Thomas Cole for a painting called *The Architect's Dream*. Town provided Cole with several books and engravings from his library and a $225.25 deposit on the painting's $500 value. The painting, completed that summer, depicts an architect, presumably either Town or Cole, reclined on a collection of books and portfolios. Surrounding him is an imaginary landscape showing buildings of various styles, including an Egyptian pyramid, Greek and Roman temples, and a Gothic church. The painting is now on display in the Toledo Museum of Art.

The covered bridges of Connecticut and Rhode Island were almost exclusively built using one of two truss designs—the Town lattice truss already discussed and the Howe truss developed by William Howe of Massachusetts in 1840. Howe's design used a series of panels, with each one consisting of diagonal timber compression members in an X pattern, with vertical iron or steel rod tension members providing additional support. Stronger than other designs at the time, it quickly became the preferred choice for wooden railroad bridges.

Some of the material contained within this book is based on the research of two noted covered-bridge historians: Richard Sanders Allen (1917–2008) and Michael C. DeVito (1906–1991). Richard Sanders Allen was a pioneer covered-bridge historian. His 40-plus years of research generated a number of books and countless articles on the subject. *Topics*, the journal of the National Society for the Preservation of Covered Bridges (NSPCB), was started by Allen in 1943 to share his research with his colleagues. His notes and extensive photograph collection are now stored in the NSPCB archives in Westminster, Vermont. Photographs from this collection have previously been included in Arcadia's publications on the covered bridges of Maine, New Hampshire, Vermont, and the recently released book on Massachusetts's covered bridges. On a local level, Michael DeVito's research focused on Connecticut bridges. In 1964, DeVito privately published *Connecticut's Old Timbered Crossings* to document Connecticut's covered bridges. Many photographs from his collection are included here.

## One

# THE BRIDGE DESIGNERS

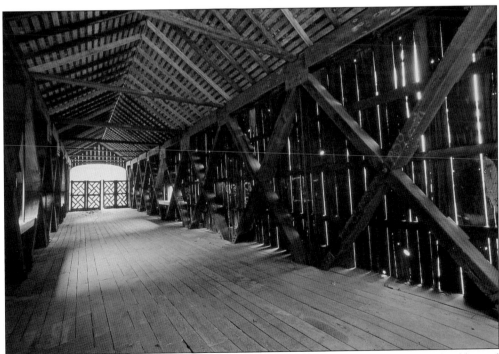

William Howe, from Spencer, Massachusetts, patented his new truss design in 1840, with additional improvements in 1850. Howe trusses can be seen in the Comstock Bridge between Colchester and East Hampton, Connecticut. Being much stronger than other designs of its time, Howe trusses became the exclusive choice for wooden railroad bridges. They are used in more Connecticut and Rhode Island covered bridges than all other truss designs. (Courtesy of Brian McKee.)

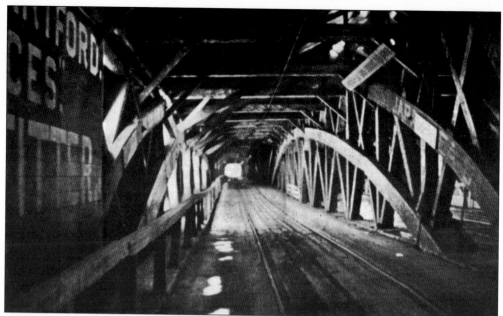

Connecticut's earliest covered bridges were likely built using Theodore Burr's truss design, which took the earlier triangle-based, multiple king post truss and added arched beams for extra support. This design is only known to have been used in a few of Connecticut's historical bridges, such as the Hartford Toll Bridge shown here. The bridge was built by Ithiel Town and Isaac Damon in 1818. (Courtesy of Richard Sanders Allen Collection, NSPCB Archives.)

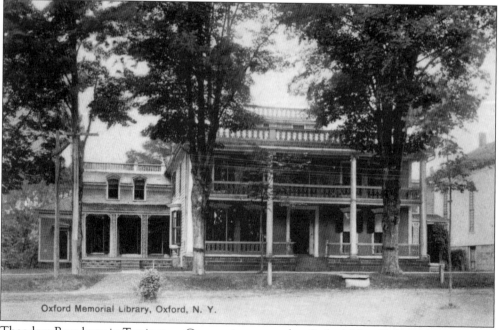

Oxford Memorial Library, Oxford, N. Y.

Theodore Burr, born in Torrington, Connecticut, moved to Oxford, New York, in the 1790s. His home is the last remaining structure known to have been built by him. It currently houses the Oxford Memorial Library, which includes the Theodore Burr Covered Bridge Resource Center dedicated to covered bridge research. (Author's collection.)

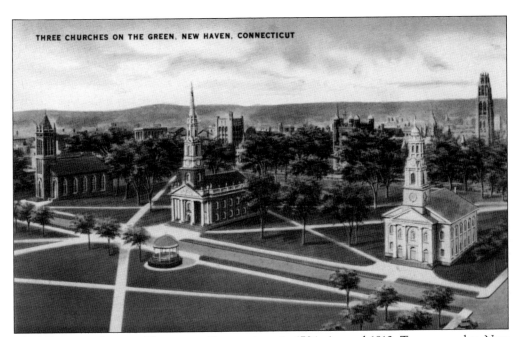

THREE CHURCHES ON THE GREEN, NEW HAVEN, CONNECTICUT

Ithiel Town was born in Thompson, Connecticut, in 1784. Around 1812, Town moved to New Haven and established himself as a builder and architect. He designed the Federal-style brick Center Church (center) erected next to David Hoadley's North Church (right). Town constructed the spire for the Center Church inside the tower and then raised it into place in less than three hours using a special windlass. (Author's collection.)

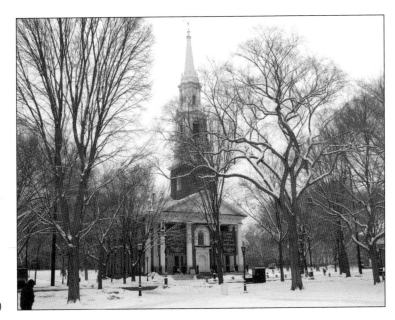

The Center Church was built between 1812 and 1814. It was constructed over a small portion of New Haven's burial ground. All the remains and gravestones were left in their original positions to be protected by the church's foundation, where a crypt was created. The crypt is open to the public. (Author's collection.)

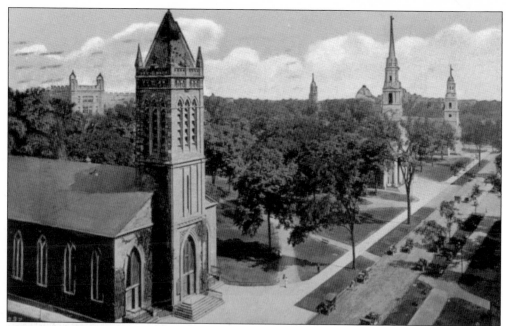

Ithiel Town designed the third church on the New Haven Green, Trinity Church, while Center Church was under construction. Trinity Church is built with local seam-faced traprock and topped with a square tower. It was one of the earliest Gothic Revival churches in America. The church was consecrated in February 1816. The pyramid on top of the tower was removed in 1930. (Above, author's collection; below, courtesy of Southern New England Telephone Company Records, Archives & Special Collections at the Thomas J. Dodd Research Center, University of Connecticut Libraries.)

Ithiel Town was granted a patent for his lattice truss design on January 28, 1820, as an effort to create a simpler plan that didn't require the specialized labor of the designs in use at the time. The lattice design is made up of a series of diagonally set planks. Town further improved the design and patented it again in 1835. A modified version of Town's truss design can be seen in two of Connecticut's remaining historical covered bridges: the West Cornwall Bridge between Cornwall and Sharon (above) and Bull's Bridge in Kent (below). (Both, author's collection.)

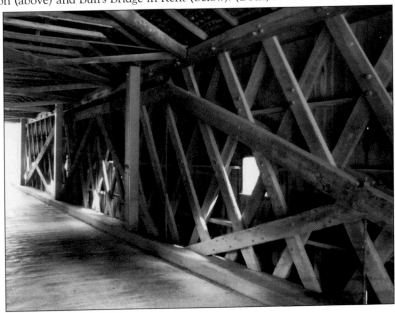

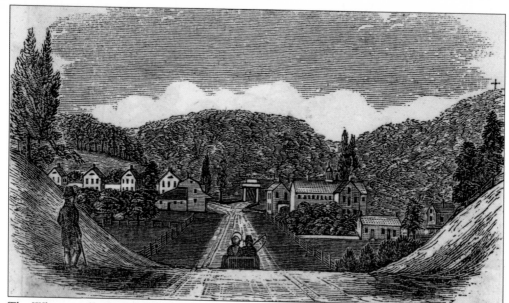

The Whitneyville Bridge originally crossed Mill River at Whitneyville, just outside New Haven. It was possibly the earliest Town lattice truss built in Connecticut, and it is said that Ithiel Town himself supervised the construction. The Whitneyville Bridge was moved in 1860 when Eli Whitney Jr. dammed the Mill River to create the Lake Whitney Reservoir. (Courtesy of Richard Sanders Allen Collection, NSPCB Archives.)

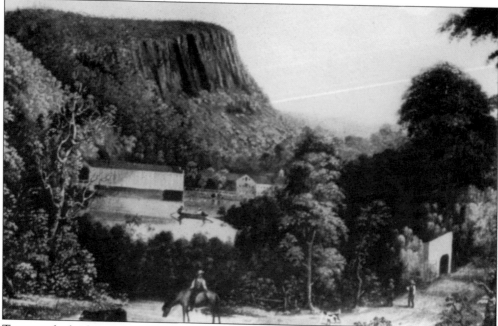

To move the bridge, chestnut cribs were built under the bridge while rollers were placed between the cribs and the bridge. It was then rolled to its new location about a quarter of a mile away over Lake Whitney on Davis Street. At one time, an entire exterior side of the bridge was painted with an advertisement for John E. Bassett & Company's hardware store in New Haven. (Courtesy of Michael C. DeVito Collection, Richard Roy.)

In 1979, students from Eli Whitney Vocational-Technical High School constructed a replica of the Whitneyville Bridge on the grounds of the Eli Whitney Museum and Workshop in Hamden, a short distance from the Davis Street site. Eli Whitney purchased the land where the museum now resides on September 17, 1798. (Author's collection.)

OLD STATE HOUSE, NEW HAVEN, CONN.

Along with Hartford, New Haven became co-capital of Connecticut in 1701. General Assembly meetings alternated between the two cities. When sitting in New Haven, they met in a statehouse, designed by Ithiel Town in 1827, on New Haven Green. In 1874, the building lost its status as a statehouse when Hartford was chosen as the sole state capital. The building fell into decay and was razed in July 1889. (Author's collection.)

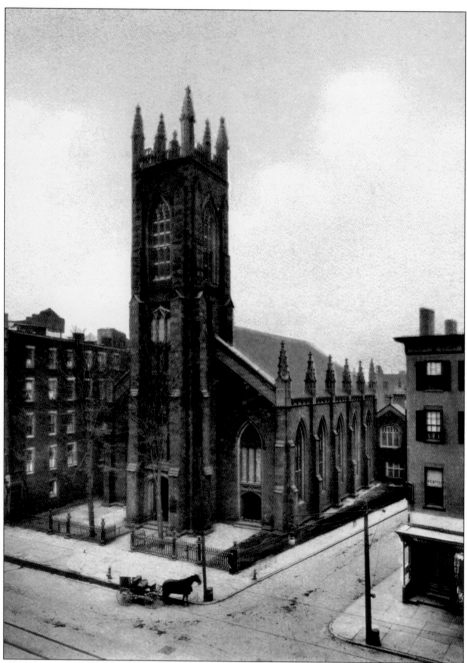

Christ Church Cathedral in Hartford is one of the oldest Gothic-style churches in the United States. It was designed by Ithiel Town and Alexander Davis from sketches prepared by the church's rector while on a trip to England. These sketches included architectural details from many churches, such as Westminster Abbey and Canterbury Cathedral. Construction began in 1827, and the church was consecrated in December 1829. The cathedral's outer walls are made from native Portland brownstone and are three feet thick. The bell tower rises 150 feet above street level and is 22.5 square feet. The open parapet at its top is an exact replica of those at York Minster. (Author's collection.)

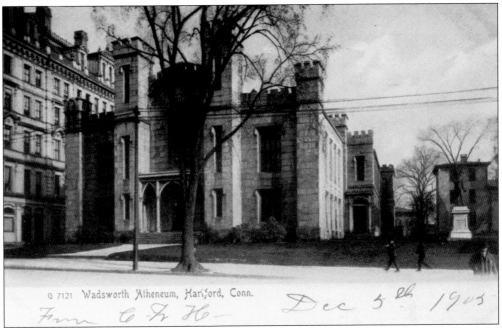

G 7121 Wadsworth Atheneum, Hartford, Conn. *Dec 5th 1905*

*From C. H. H—*

Hartford art patron Daniel Wadsworth admired the Gothic Revival style of Hartford's Christ Church built in 1828. He commissioned the church's architects, Town and Davis, to create his fine arts gallery. The Wadsworth Atheneum opened as America's first public art museum. The name "Atheneum" was chosen in honor of Athena, the Greek goddess of wisdom. The structure was divided into three sections that were separated by sturdy brick walls to reduce the risk of fire. (Author's collection.)

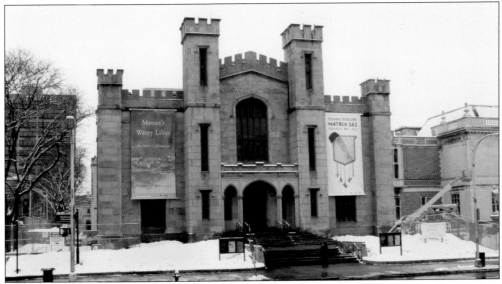

Wadsworth almost immediately expanded his plan for a fine arts gallery to include a Connecticut Historical Society and the Young Men's Institute, precursor of the Hartford Public Library. The atheneum first featured works collected by Wadsworth and later added large bequests from other Hartford notables, such as Elizabeth Hart Jarvis Colt (the wife of Samuel Colt) and J. Pierpont Morgan. (Author's collection.)

The Russell House in Middletown, Connecticut, was designed by Ithiel Town and built between 1828 and 1830. The house was the home of Samuel Russell, a central figure in the China trade. Five generations of the Russell family occupied the house until 1937, when it was deeded to Wesleyan University by Thomas Macdonough Russell Jr. The house was known as Honors College from 1937 to 1996. (Author's collection.)

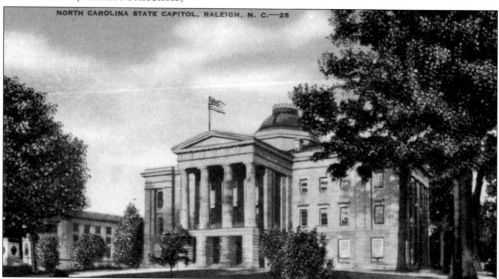

On June 21, 1831, the North Carolina Statehouse in Raleigh was accidentally destroyed by fire. Ithiel Town and Alexander Davis proposed a Greek Temple plan, similar to their capitols in Connecticut and Indiana. The five-member building commission initially accepted a plan by William Nichols but later asked Town and Davis to modify Nichols's plan. Construction began in 1833, with the Greek Revival structure being completed in 1840. (Author's collection.)

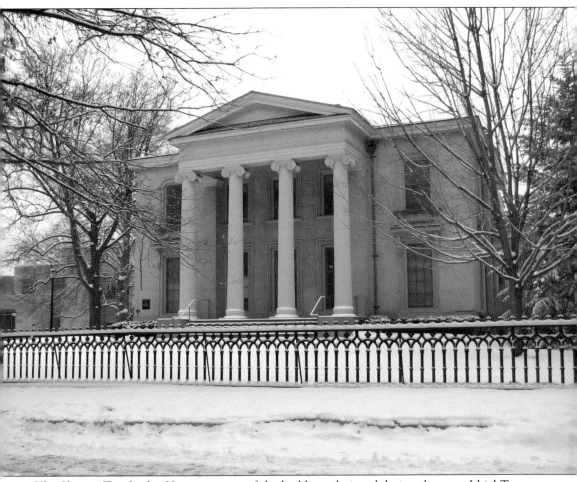

The Skinner-Trowbridge House was one of the buildings designed during the years Ithiel Town and Alexander Davis were in business together. Located at 46 Hillhouse Avenue in New Haven, the house was originally designed for lawyer Aaron Skinner, who bought the lot for $1,000 in September 1830. In 1858, Skinner sold the house to Judge W.W. Boardman, who had it remodeled in a more eclectic style. In 1907, another new owner, Rutherford Trowbridge, expanded the mansion with a large dining room and two-story kitchen/service addition on the west. The building now houses Yale University's International Center for Finance. (Author's collection.)

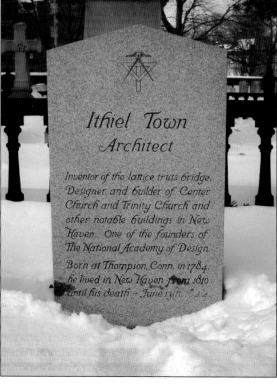

At 56 Hillhouse Avenue, Evans Hall was designed by Davis and Town and built in 1837 for Elizabeth Cogswell Davenport Apthorp. It was deeded to Yale in 1877, sold by the university in 1916, and then resold to Yale in 1928. It was used as a residence, a dormitory for women, and academic offices until it became part of the School of Organization and Management in 1974. (Author's collection.)

Ithiel Town died June 13, 1844, in New Haven at the age of 59. He is buried in the city's Grove Street Cemetery. (Author's collection.)

# *Two*

# NORTHWESTERN CONNECTICUT BRIDGES

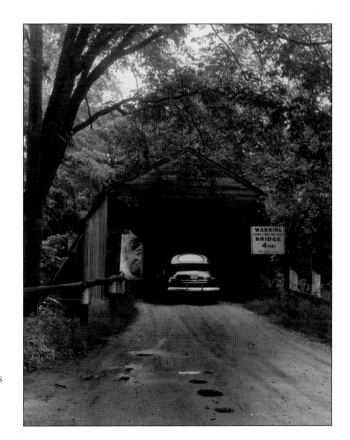

Two of Connecticut's three remaining historical covered bridges are within a few miles of each other in the northwestern part of the state. Bull's Bridge in Kent (pictured here) and the West Cornwall Bridge at West Cornwall both span the Housatonic River in Litchfield County. (Courtesy of Southern New England Telephone Company Records, Archives & Special Collections at the Thomas J. Dodd Research Center, University of Connecticut Libraries.)

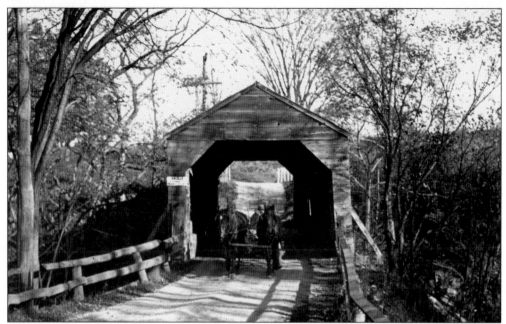

Bull's Bridge is named for Isaac and Jacob Bull, who started an ironworks in Kent in 1760 and built the first bridge over this gorge. The original bridge was built at a cost of $3,000 to aid in transporting iron from Kent area furnaces to the Hudson River at Newburgh, New York. The current bridge was built in 1842. (Courtesy of NSPCB; Basil Kievit photograph.)

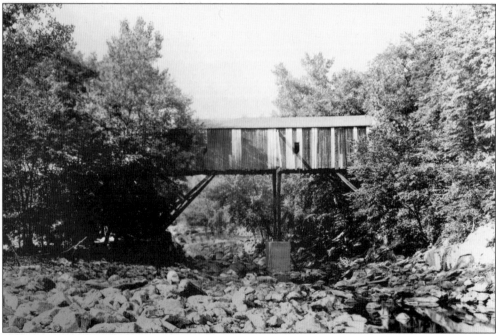

Bull's Bridge was raised 20 feet to keep it above potential floodwaters when the Connecticut Light & Power Company built a plant in the area between 1901 and 1904. Repairs were made to the bridge in 1949 after an inspection revealed that the bottom chords were split in several places and rotted on both ends. (Courtesy of Michael C. DeVito Collection, Richard Roy.)

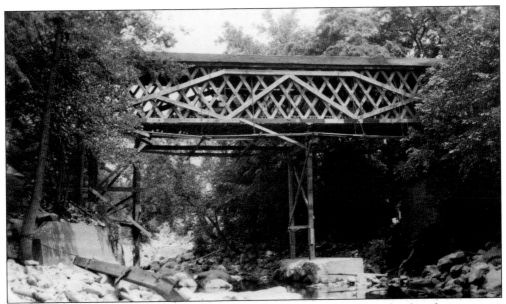

Bull's Bridge has an unusual truss design, which is visible in this photograph taken during repairs in 1949. It includes a Town truss sandwiched between queen post trusses. The West Cornwall Bridge uses a similar design. The queen post trusses were probably added after the bridge's initial construction. In 1949, the state highway department replaced one of the lower chords while the others were spliced with iron channels. The trunnels holding the lattice truss together were replaced, and a new queen post truss was added. Steel I beams were added under the floor to strengthen the bridge. The side boards were lengthened to conceal the steel beams. (Above, courtesy of Richard Sanders Allen Collection, NSPCB Archives; below, author's collection.)

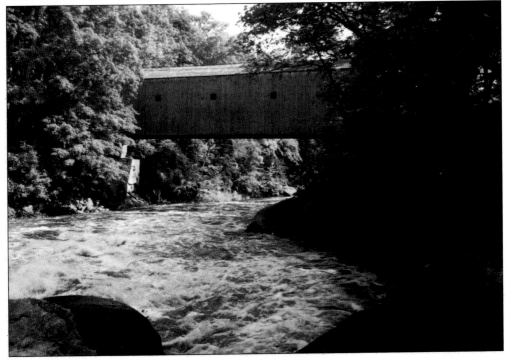

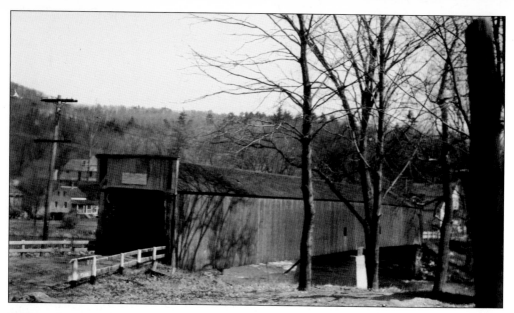

While concrete evidence of the West Cornwall Bridge's construction date has not yet been found, research by Cornwall town historian Michael Gannett uncovered an article in the *Litchfield Enquirer* of August 4, 1864, noting that the bridge over the Housatonic River at West Cornwall that had been under construction for the previous two months was completed and open to travel. The construction date was previously thought to be 1841. A bridge at this location was swept away during flooding in 1837, and in January 1841, high water either damaged or destroyed the existing bridge at that time. During the winter of 1960 to 1961, it was threatened by an ice jam. On February 26, 1961, the ice was dynamited, causing the water level to drop back below the bridge. (Above, courtesy of Andy Rebman; below, courtesy of Richard Sanders Allen Collection, NSPCB Archives.)

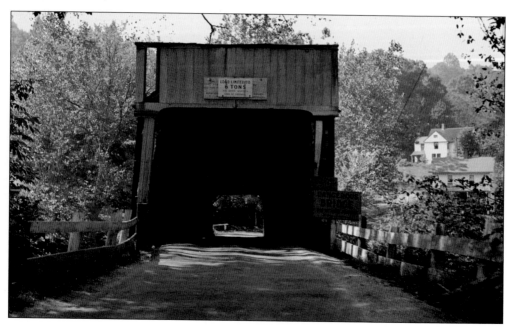

Earlier bridges at this location were once called Hart's Bridge, after one of Cornwall's earlier settlers. After a post office was established at West Cornwall in 1841, the bridge became known by that name. The present West Cornwall Bridge, also known as Hart Bridge, is 172 feet long and stands at the western side of West Cornwall, crossing the Housatonic River to Sharon. (Courtesy of Richard Sanders Allen Collection, NSPCB Archives.)

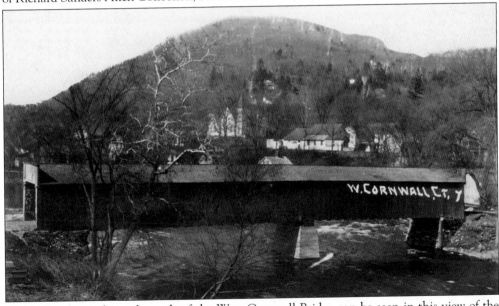

The squared portals on the ends of the West Cornwall Bridge can be seen in this view of the downstream side. They were replaced with a more typical gable roof during repairs in the 1940s. The two spans are not of equal length. The west span is nearly 95 feet long, and the east span is 77 feet long. (Courtesy of Todd Clark.)

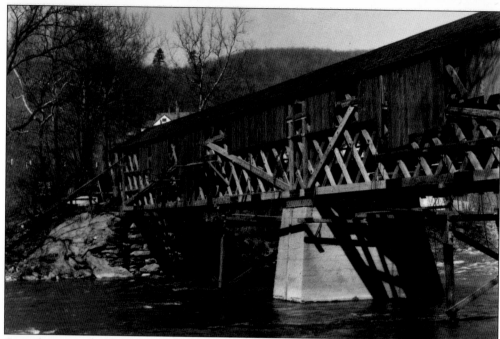

Over the years, the West Cornwall Bridge had fallen into a state of disrepair. In 1945, a 20-ton oil truck fell through the floor, forcing closure of the bridge. The state highway department provided long overdue repairs, as shown in these photographs from April 1946 (above) and June 1946 (below). Broken bottom chords were replaced, modifications were made to the queen post trusses, a new hemlock floor was installed, more windows were added, and the square portals were removed. Another significant change was made in 1973 when a steel deck was inserted to support vehicles traveling through the bridge. (Both, courtesy of Michael C. DeVito Collection, Richard Roy.)

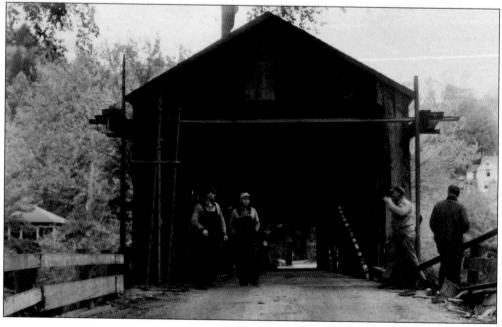

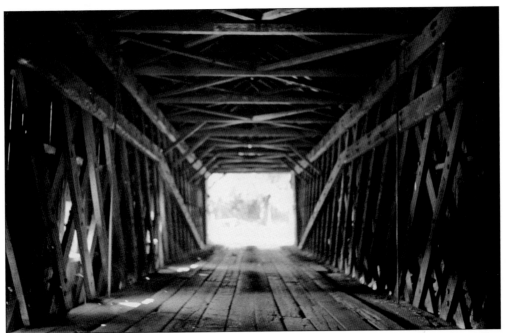

The West Cornwall Bridge has an unusual truss design shown in this Richard Sanders Allen photograph from September 29, 1940. The Town lattice truss is sandwiched between two queen post trusses. Only two other existing bridges currently share this design: Bull's Bridge a few miles to the south and the Schofield Ford Bridge in Bucks County, Pennsylvania. (Courtesy of Richard Sanders Allen Collection, NSPCB Archives.)

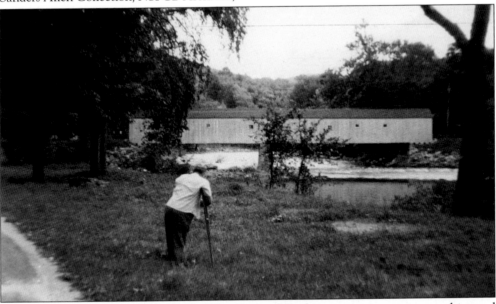

Michael C. DeVito, pictured here at the West Cornwall Bridge, spent many years researching and documenting Connecticut's covered bridges. DeVito, who was stricken with polio when he was 18 months old, took up the study of covered bridges in his 40s. He wrote a number of articles in covered bridge society newsletters and, in 1964, self-published *Connecticut's Old Timbered Crossings*, which was based on his research. (Courtesy of Michael C. DeVito Collection, Richard Roy.)

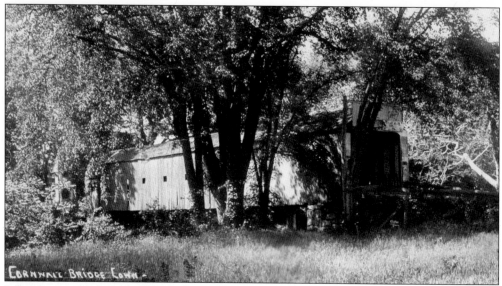

It has been said that Ithiel Town himself supervised the construction of the bridge over the Housatonic River at the community of Cornwall Bridge shortly after he built the Whitneyville Bridge in Hamden. The single-span structure was 128 feet long and built with oak trusses using Town's patented design. (Courtesy of Todd Clark.)

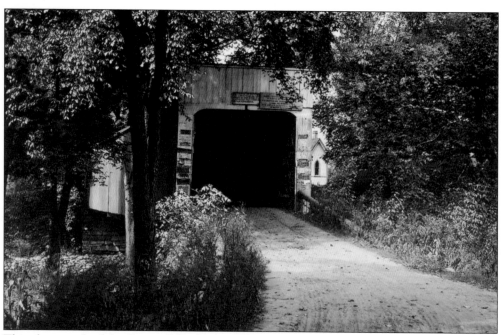

This photograph of the Cornwall Bridge was taken in August 1916. This bridge shows a squared portal similar to the ones on the West Cornwall Bridge (before it was repaired in 1946) located four miles upstream. (Courtesy of F.H. DeMars Collection, Margaret Giles.)

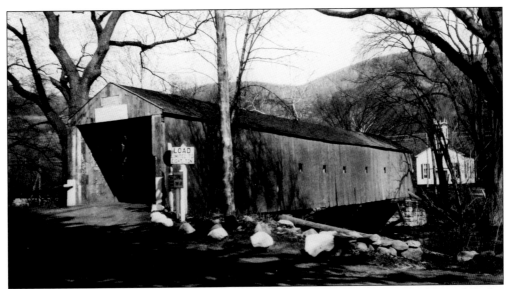

In November 1929, Bernhardt Wall of Lime Rock, Connecticut, organized the Covered Bridge Preservation Association to save the Cornwall Bridge and others in New England from destruction. As a result of their efforts, repairs were made to the bridge. It remained open to pedestrian traffic after the concrete replacement bridge was completed in late 1930. In the background is St. Bridget's Church in Sharon. (Courtesy of NSPCB; D.M. Wheeler photograph.)

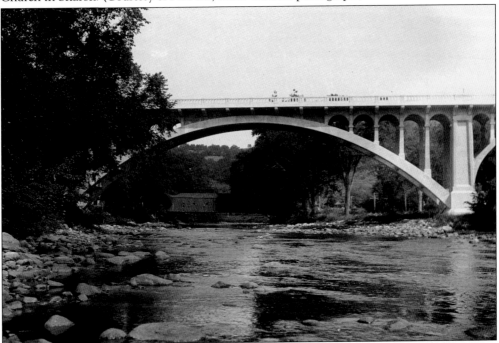

The Cornwall Bridge can be seen through the arch of the concrete bridge that replaced it. Construction of the state's largest concrete arch bridge began in July 1929. During the March 1936 flood, the covered bridge was carried downstream, where it passed under the new concrete bridge and took out the steel Swift's Bridge farther downstream. Neither Cornwall nor Swift's Bridge were replaced. (Courtesy of Richard Sanders Allen Collection, NSPCB Archives.)

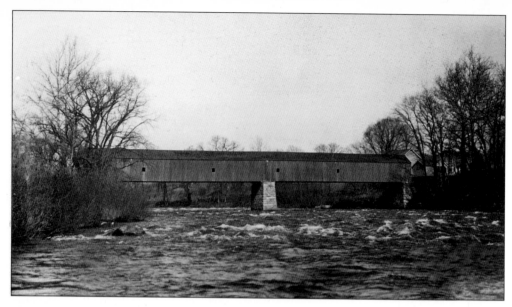

Minutes from an 1832 town meeting indicated that the bridge at Gaylordsville was "in a ruinous and dangerous condition." In May 1832, the Connecticut General Assembly incorporated the Gaylords Bridge Toll Bridge Company to build and maintain a new bridge. They raised $1,400 by selling stock at $25 per share. Shareholders and their family members were exempted from paying the tolls. The bridge cost $1,500.14 to build. When the dam at Gaylordsville failed in the spring of 1854, it caused a flood 23 feet above the normal water level, which destroyed the 1832 bridge. Above is a 1913 photograph of the covered bridge built at Gaylordsville in 1876 for about $3,000. The bridge was downstream from the present crossing of US Route 7. (Above, courtesy of NSPCB Archives, Charles White photograph; below, courtesy of Andy Rebman.)

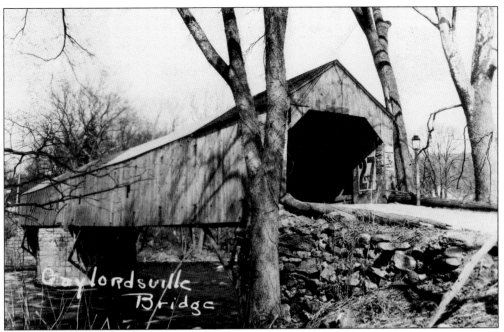

An October 9, 1927, *Hartford Courant* article stated that ice and flood carried away a bridge at Gaylordsville in 1873. The pictured bridge, built in 1876, would have been its replacement. In 1926, the two-span Town lattice truss bridge that served the town for 50 years was bypassed by a new bridge upstream. The wooden bridge remained in place after the new one was completed. (Courtesy of Michael C. DeVito Collection, Richard Roy.)

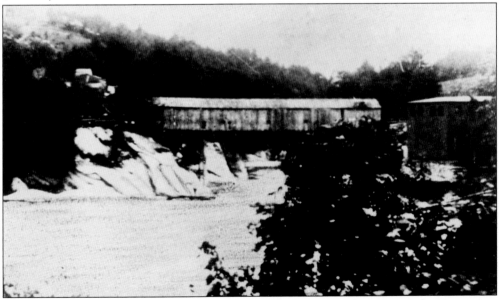

The Bridgewater Falls Bridge, also known as the Lover's Leap Bridge, crossed the Housatonic River on Pumpkin Hill Road near Lover's Leap State Park, east of the Still River. The single-span Town lattice truss bridge was probably removed in 1895 when a new lenticular through truss bridge was built at this location by the Berlin Iron Bridge Company. (Courtesy of Michael C. DeVito Collection, Richard Roy.)

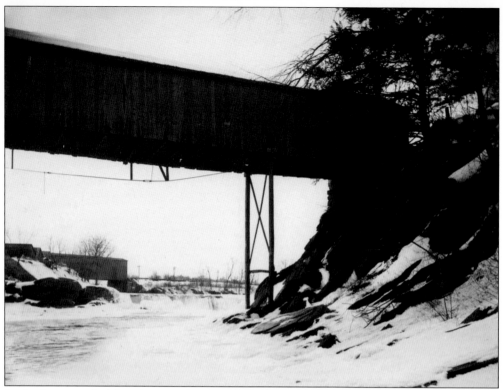

In the foreground of this photograph, taken from the Housatonic River, is the Bridgewater Falls Bridge located south of New Milford. In the background is the Housatonic Railroad Bridge at the mouth of Still River. The railroad bridge was replaced around 1901. (Courtesy of Richard Sanders Allen Collection, NSPCB Archives.)

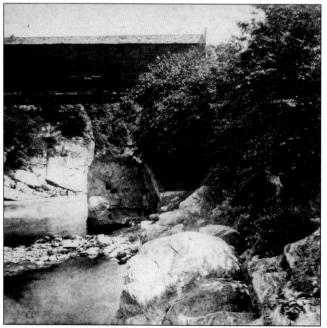

This covered railroad bridge on the Housatonic Railroad was probably the Still River crossing near Lover's Leap State Park, south of New Milford. Between 1840 and 1888, the Housatonic Railroad also had a three-span, 339-foot-long Howe truss bridge south of New Milford. (Courtesy of Todd Clark.)

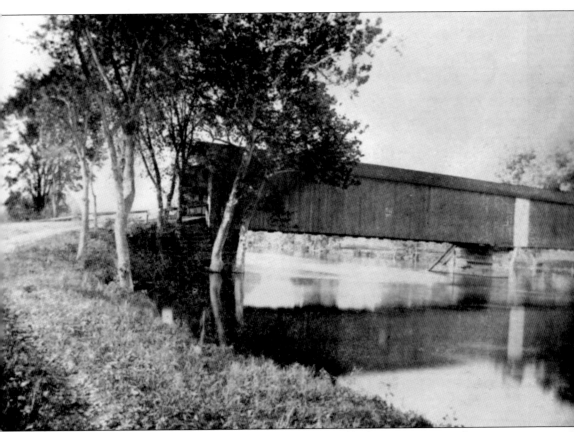

The first known bridge over the Housatonic River in New Milford was an open wooden structure built in 1737. It was carried away by floodwaters in 1755. Two more open bridges were swept away before the town of New Milford built the first toll bridge in 1758. People crossing the bridge to attend church services on Sundays were exempt from paying the toll. It isn't yet known when the first covered bridge at New Milford was built, but it was lost when the Gaylordsville Dam failed in the spring of 1854. The resulting flood first destroyed the Gaylordsville Covered Bridge, then the Boardman's Bridge four miles downstream, and finally, the New Milford Bridge two miles farther downstream. A new covered bridge was built at New Milford in the same year. (Courtesy of Michael C. DeVito Collection, Richard Roy.)

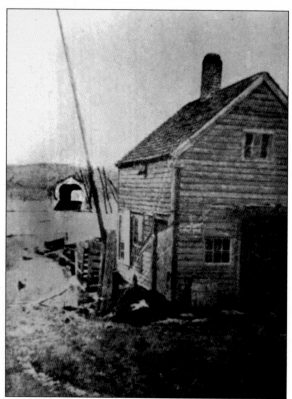

This photograph of the 1854 New Milford Bridge and Toll House was taken during a flood of the Housatonic River in 1865. The bridge survived that flood with only minor damage. It was eventually carried away by ice and floodwaters on March 8, 1904. (Courtesy of Michael C. DeVito Collection, Richard Roy.)

The Housatonic Railroad built a repair shop on the west side of the Housatonic River north of Falls Village at Amesville. A siding was built from the main line on the east side of the river over the falls to the shops. (Courtesy of Allyn Fuller Collection, Archives & Special Collections at the Thomas J. Dodd Research Center, University of Connecticut Libraries.)

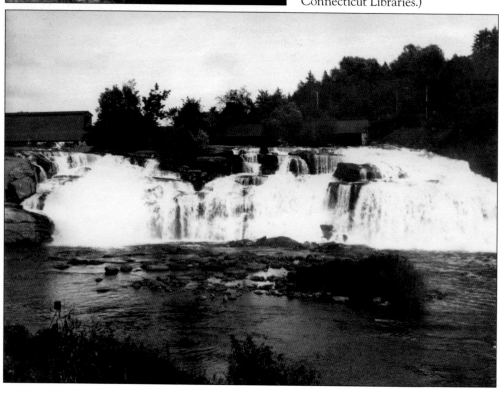

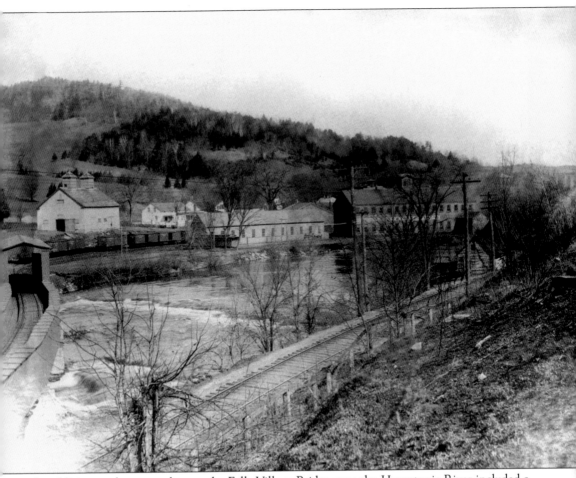

In addition to the covered span, the Falls Village Bridge over the Housatonic River included a long, curved pony truss (an enclosed wooden truss without a roof or other bracing) at the eastern end. The Housatonic Railroad repair shops at Amesville were located at the site of the former Ames Iron Works, which closed after the Civil War. The area was known as Canaan Falls until the Housatonic Railroad was constructed in 1841. The station near the falls was named Falls Village, and the area around the station became known by that same name. The railroad's repair facility was closed shortly after the line merged with the New Haven Railroad in 1898. (Courtesy of Allyn Fuller Collection, Archives & Special Collections at the Thomas J. Dodd Research Center, University of Connecticut Libraries.)

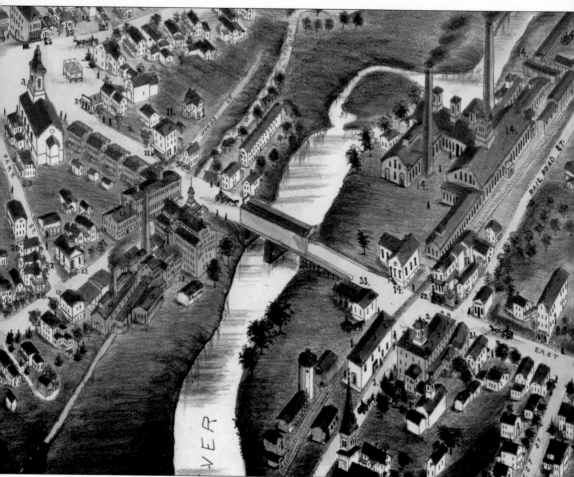

O.H. Bailey's 1879 map of Thomaston shows a two-span covered bridge crossing the Naugatuck River on East Main Street (US Route 6). Originally known as Plymouth Hollow, the area was incorporated as Thomaston in 1875 to honor clock maker Seth Thomas. The bridge was "recently demolished" and replaced by an iron bridge at the time the town history was written in 1895. The Naugatuck Railroad had a covered bridge over the Naugatuck River about a mile and a half north of Thomaston until it burned on the afternoon of May 19, 1898. The bridge had been supported by trestles after the trusses were damaged in an accident a few days earlier that killed one man at the scene and fatally injured another. A temporary bridge was in service the following evening. After the Thomaston railroad bridge burned, the only covered bridge remaining on this line was one south of Thomaston at Waterville. (Courtesy of Geography and Map Division, Library of Congress.)

# *Three*

# Farmington River Bridges

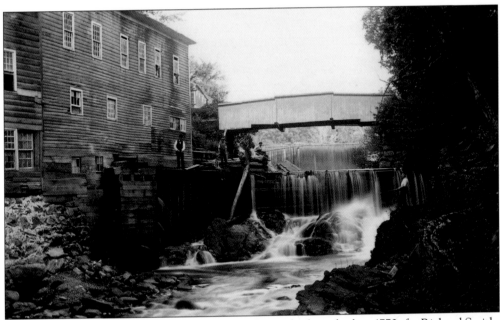

The first bridge over the Still River at Roberstville was built in the late 1770s for Richard Smith, owner of the nearby forge. The pictured bridge was likely built in the late 1800s. It has been replaced at least twice since then. The current concrete structure was built after the 1955 flood. The bridge was adjacent to the Union Chair Company, which went out of business in 1890. (Courtesy of F.H. DeMars Collection, Margaret Giles.)

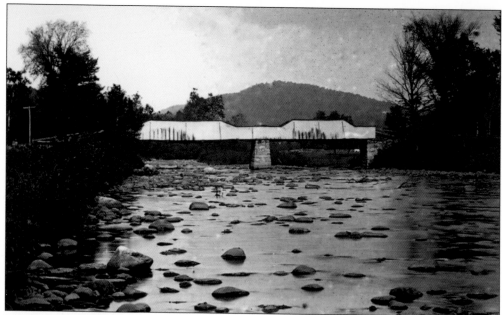

The Spencer Bridge crossed the West Branch of the Farmington River at Colebrook River, just south of the Massachusetts border. The bridge was authorized by a Colebrook town meeting on November 28, 1884. It was probably replaced in the first decade of the 20th century. The final bridge at this location was a concrete structure that still exists under the southern end of Colebrook River Lake. (Courtesy of F.H. DeMars Collection, Margaret Giles.)

The French Bridge crossed Sandy Brook less than 100 yards upstream from its junction with Still River near Robertsville. This photograph may have been taken by Una Clingan, a local photographer of the early 20th century whose collection was later purchased by Frank DeMars. The first bridge at this location was built in 1771. (Courtesy of F.H. DeMars Collection, Margaret Giles.)

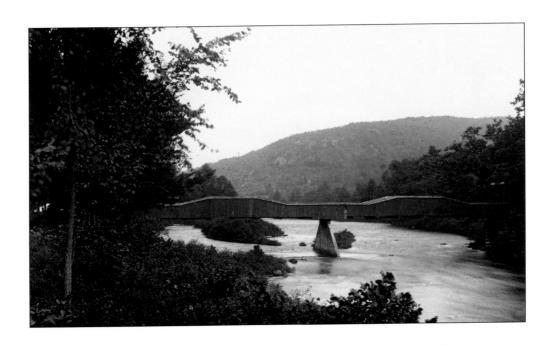

The Long Bridge (above) was a two-span pony truss crossing the West Branch of the Farmington River in the Pleasant Valley section of Barkhamsted. On January 24, 1891, the Long Bridge (below) and a bridge over the Farmington's East Branch at Barkhamsted Hollow were washed away by floodwaters. The Long Bridge was replaced with a steel bridge that was washed away by the 1938 flood. The present steel truss bridge at Pleasant Valley was built in 1939. The location of the Barkhamsted Hollow Bridge is presently under the Barkhamsted Reservoir, which was created in the late 1930s to supply water for the city of Hartford. (Both, courtesy of F.H. DeMars Collection, Margaret Giles.)

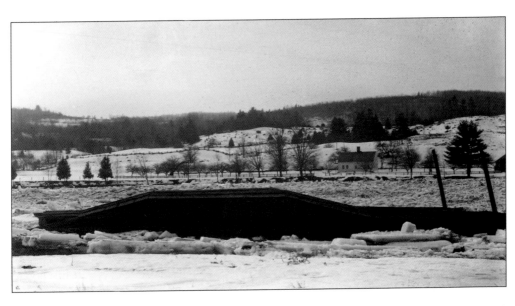

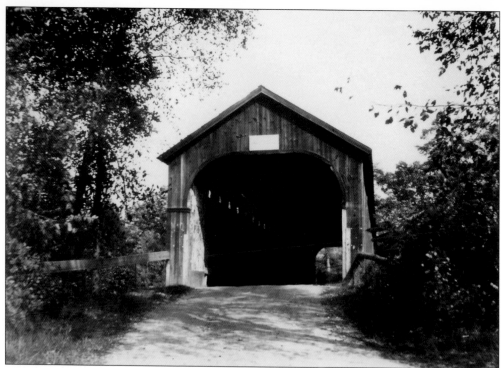

The Black Bridge over the West Branch of the Farmington River on Black Bridge Road at Pine Meadow was a two-span Howe truss built in 1874. The Pine Meadow area has experienced a number of floods over the years. In 1866, a freshet carried away a bridge between Pine Meadow and North Village (now New Hartford). It is not known if that was the location of Black Bridge or the one farther to the north. In 1878, a flood carried away a railroad bridge at Pine Meadow. The East and West Branches of the Farmington River join together about a mile below this point. (Above, courtesy of Andy Rebman; below, courtesy of Todd Clark.)

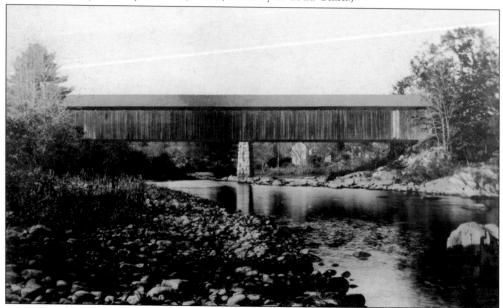

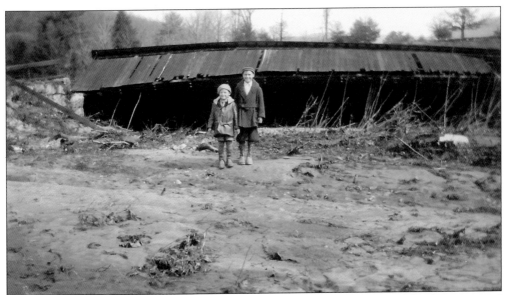

At 7:50 a.m. on Wednesday, March 18, 1936, the combination of an ice jam and floodwaters caused the Greenwood Pond dam to fail. The dam was a power source for the Greenwoods Cotton Mill in New Hartford and crossing point for the railroad. The resulting rush of water carried the Black Bridge off its abutments and smashed it beyond repair. (Courtesy of Todd Clark.)

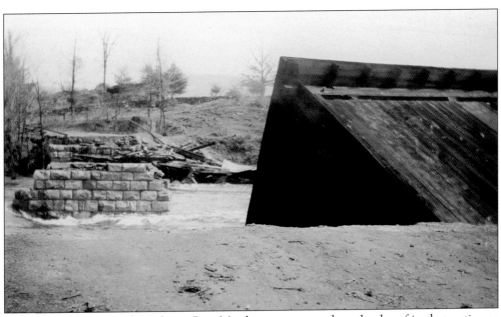

It was said that the Black Bridge at Pine Meadow was as sound on the day of its destruction as it was when first constructed. A new iron bridge was opened on October 26, 1936, less than 60 days after the project was initiated, at a cost of $10,500. The ribbon cutting was done by John E. Smith, a former town official and, reportedly, one of the builders of the covered bridge. (Courtesy of Todd Clark.)

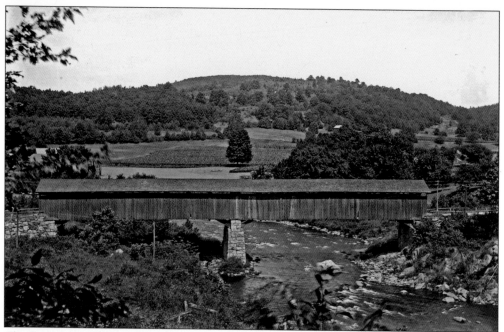

The Satan's Kingdom Bridge was a two-span, 227-foot-long structure of Burr arch design that crossed the Farmington River. It was built in the 1850s near a point where the river enters a gorge on what is now Route 44. Satan's Kingdom is a mountainous area in the eastern part of New Hartford. (Courtesy of F.H. DeMars Collection, Margaret Giles.)

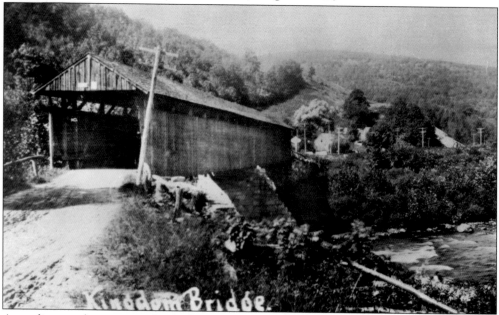

According to a letter written by Carlos O. Holcomb of New Britain, Connecticut, in May 1913, the bridge was built in 1859. Holcomb, who was 16 at the time, carried timbers for the Satan's Kingdom Bridge with his oxen from the Collinsville depot to the bridge location. He was the son of Carlos Holcomb, who was a New Hartford selectman when the bridge was built. (Courtesy of Michael C. DeVito Collection, Richard Roy.)

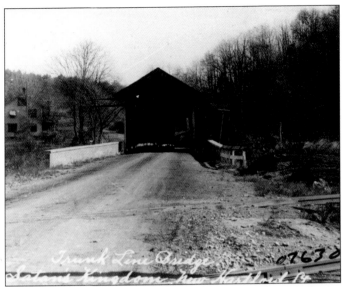

Tracks of the Connecticut Western Railroad (later known as the Central New England Railway) and New Haven & Northampton Railroad both passed by the western end of the bridge at Satan's Kingdom. The steel bridge that replaced it was washed out in a flood in August 1955. (Courtesy of Leroy Roberts Collection, Archives & Special Collections at the Thomas J. Dodd Research Center, University of Connecticut Libraries.)

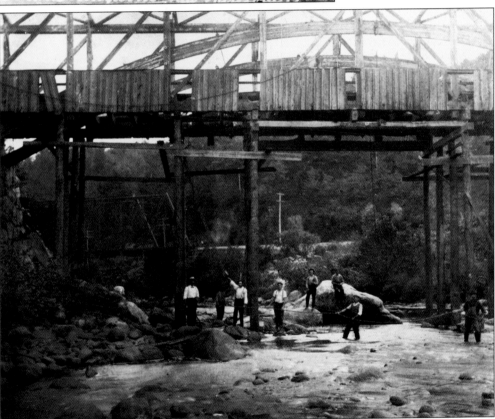

The roof of the Satan's Kingdom covered bridge was removed during the fall of 1912. The bridge was closed, repaired, and reopened multiple times between 1913 and 1915. Heavy poles and timbers added for support would be carried away during the following spring's floods. The bridge was closed for the final time in February 1916. This picture was taken in 1916 while the bridge was being dismantled. (Courtesy of Michael C. DeVito Collection, Richard Roy.)

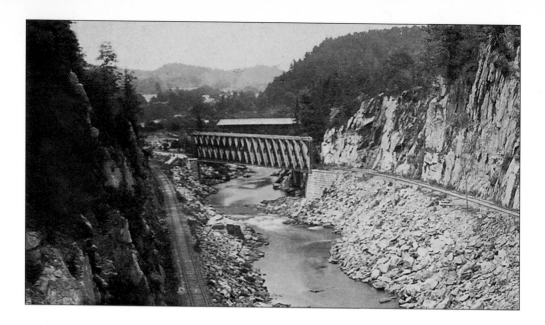

The Connecticut Western Railroad chose to replace its uncovered wooden truss bridge at Satan's Kingdom (above) after the failure of a similar bridge at Tariffville. The new bridge (below) was successfully tested on July 19, 1878. The highway bridge at Satan's Kingdom is in the background. The Connecticut Western Railroad and New Haven & Northampton Railroad ran side by side through Satan's Kingdom. Both lines eventually came under the control of the New Haven Railroad. (Above, courtesy of Todd Clark; below, courtesy of Richard Sanders Allen Collection, NSPCB Archives.)

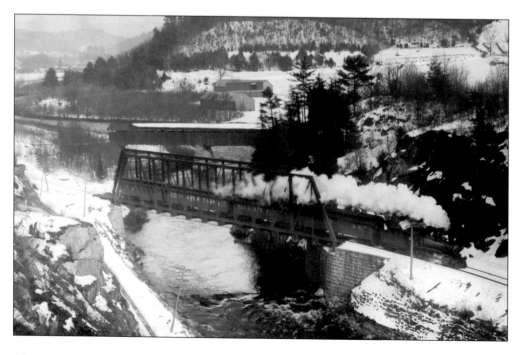

The River District Bridge, or Town Bridge, crossed the Farmington River on Town Bridge Road a mile north of Collinsville. An October 1894 *Hartford Courant* article stated that the bridge was a 104-foot-long covered structure built in 1870, the third one at this location since 1856. The first was lost during a gale (no date mentioned), and the second one was carried off by the freshet of 1869. (Courtesy of Michael C. DeVito Collection, Richard Roy.)

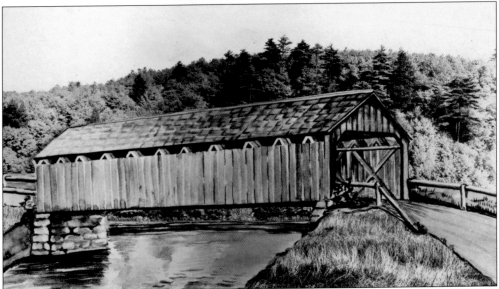

Here, the artist sketched his impression of the River District Bridge over a photograph of the site. The *Hartford Weekly Times* of February 18, 1860, stated that the "large covered bridge across the Farmington river, one mile above this village [Collinsville], known as Pettibone's bridge, was blown down at 10 o'clock this morning, smashing it completely." This was probably the undated gale mentioned in the 1894 article referenced above. (Courtesy of Michael C. DeVito Collection, Richard Roy.)

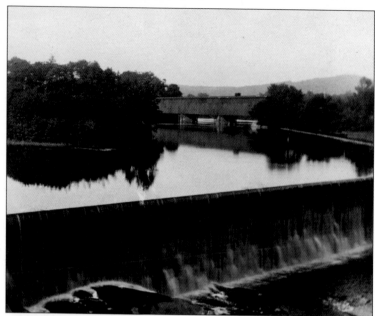

This three-span New Haven & Northampton Railroad bridge crossed the Farmington River in the northern part of Collinsville. It was a Howe truss structure built in 1870 when the railroad extended its line to Pine Meadow, five miles to the north. In 1876, the line was extended another mile to New Hartford. (Courtesy of Richard Sanders Allen Collection, NSPCB Archives.)

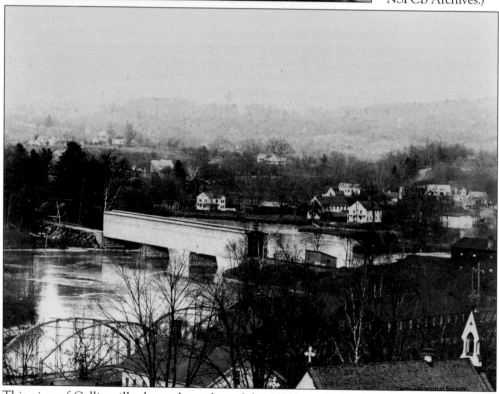

This view of Collinsville shows the arches of the 1893 iron highway bridge in the lower left foreground and the 1870 railroad covered bridge upstream from it. The New Haven & Northampton Railroad became part of the New Haven system in 1887. The covered bridge over the Farmington River at the northern part of Collinsville was replaced around 1904. (Courtesy of Canton Historical Museum.)

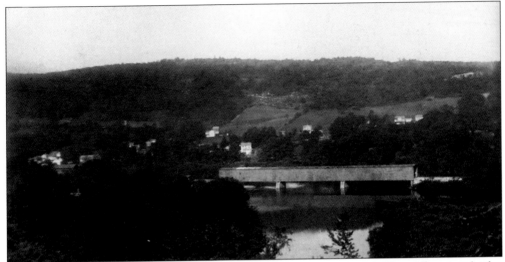

The Collinsville railroad bridge was replaced with a three-span iron truss. The replacement bridge was called Three Bridges because it looked like three separate structures crossing the river. Three Bridges was removed after the August 1955 flood destroyed the railroad tracks in town. The stone piers still remain. (Courtesy of Canton Historical Museum.)

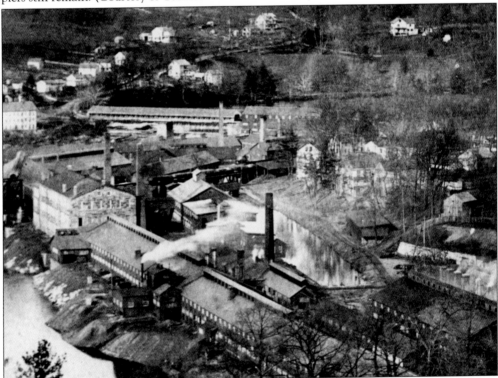

The covered highway bridge at Collinsville (upper left) replaced an 1831 wooden bridge built by the Collins Company. It featured a wide roadway and covered sidewalks. In its later years, the sidewalks became unsafe and were closed. An iron bridge with arched girders replaced it in 1893. The iron bridge was washed away during the August 1955 flood. (Courtesy of Michael C. DeVito Collection, Richard Roy.)

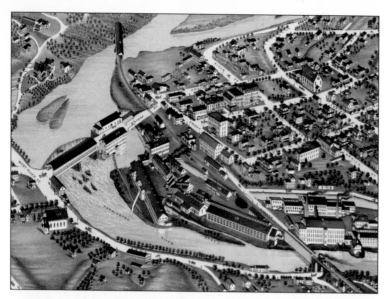

O.H. Bailey's 1878 map of Collinsville shows the three bridges in the center of town. At the south end (lower right) was a deck truss that may have been built when the line was constructed in 1850. It was replaced in the late 1870s. (Map reproduction courtesy of the Norman B. Leventhal Map Center at the Boston Public Library.)

Richard's Bridge crossed the Farmington River at the northwest edge of Unionville. It was replaced with an iron lenticular bridge built by the Berlin Iron Bridge Company in 1895. The iron bridge was lost during the flooding of August 1955. The only known image of the covered bridge is on O.H. Bailey's 1878 bird's-eye view of Unionville. (Courtesy of Map and Geographic Information Center [MAGIC], University of Connecticut Libraries.)

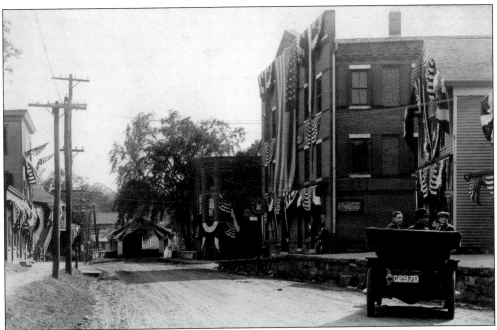

On September 20, 1911, all businesses and factories were closed when Unionville hosted the Fireman's Field Day, an annual gathering of fire companies from around the state. Downtown buildings, along with the covered bridge, were decorated for the occasion. The celebration started at 11:00 a.m. with a parade. As many as 500 firefighters, with their equipment and vehicles, marched along the five-mile long parade route and were accompanied by six or seven bands and drum corps. After passing the reviewing stand at the town hall, the parade crossed the covered bridge to Riverside Grove, where a meal provided by the ladies of Unionville was waiting for them. The day's festivities also included a number of sporting events, a concert by Colt's Armory Band, dinner, and an evening dance. (Above, courtesy of Richard Sanders Allen Collection, NSPCB Archives; below, courtesy of Clifford Thomas Alderman.)

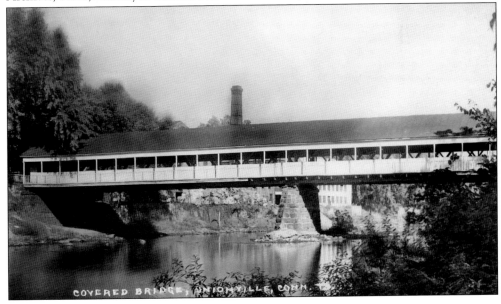

COVERED BRIDGE, UNIONVILLE CONN.

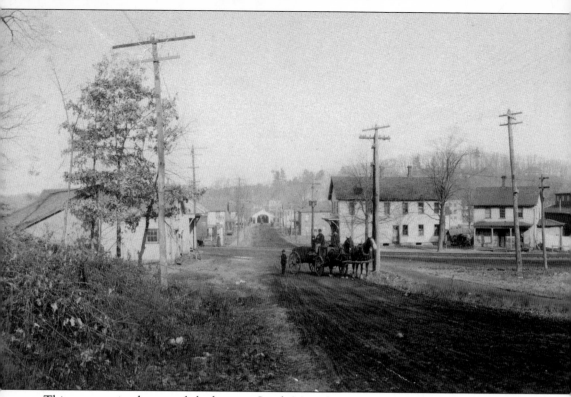

This panoramic photograph looking up South Main Street towards Unionville was probably taken around 1910. The New Haven & Northampton Railroad, chartered in June 1846, reached Unionville in 1850. The passenger depot, far right in the photograph, still stands. Passenger and freight service in Unionville ended in the 1960s. The Unionville covered bridge in the left

background was constructed in 1859 to facilitate the transport of goods between the freight depot and the main business district on the north side of the Farmington River. (Courtesy of Richard Sanders Allen Collection, NSPCB Archives.)

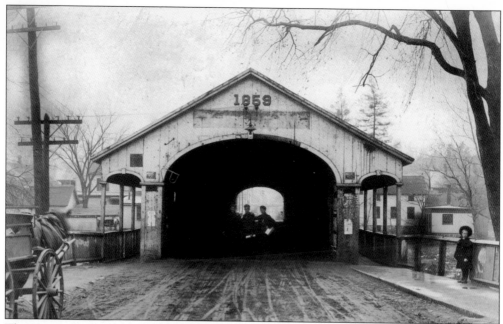

The Unionville Bridge was supported by a two-span Howe truss and had covered walkways on both sides. In November 1921, the town voted to replace the covered bridge, which was thought to be unsafe. The bridge was removed in August 1922 to make room for the steel pony truss bridge replacement. The steel bridge was destroyed by the Great Hurricane of 1938. (Courtesy of Todd Clark.)

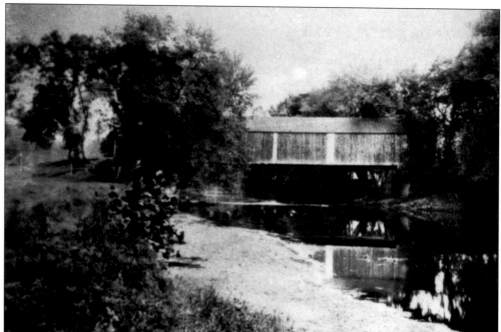

The Old Red Bridge was a single-span Town lattice truss that carried traffic over the Farmington River on what is now Route 4 at Farmington. After developing a noticeable sag, it was replaced with a steel bridge in 1904. (Courtesy of Richard Sanders Allen Collection, NSPCB Archives.)

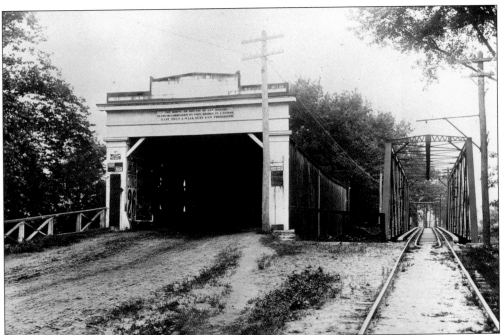

The Old Red Bridge with its squared, ornate portals was built by Sam Dickinson in 1831. The tracks next to the bridge belonged to the Farmington Street Railway, which transported passengers between West Hartford and Unionville. In 1901, the 40-minute ride cost 15¢. (Courtesy of Richard Sanders Allen Collection, NSPCB Archives.)

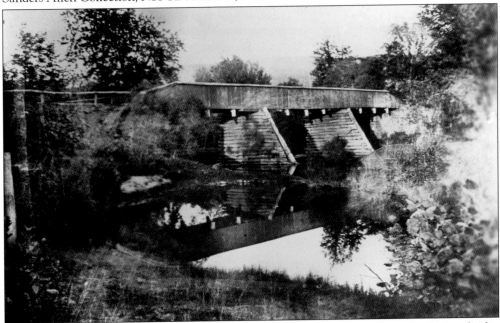

Route 44 now crosses the Farmington River at the location of this three-span pony truss bridge in Avon. The bridge cost less than $1,000 to build in 1878. It was one of many bridges washed away on March 1, 1896, when heavy rains and warm weather brought the Farmington River to its highest level since the flood of 1854. (Courtesy of Michael C. DeVito Collection, Richard Roy.)

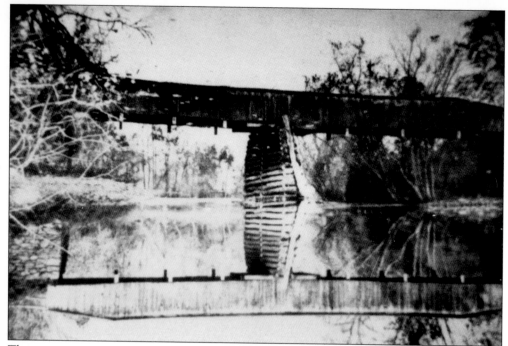

The two-span pony truss bridge in the eastern part of Avon over Cider Brook, a tributary of the Farmington River, was built in 1883 for $1,400. The first Cider Brook Bridge was built in 1832, replacing the Meetinghouse Bridge two miles or so to the north. This bridge was replaced with a steel truss bridge in 1904. The steel truss was replaced in 1950. (Courtesy of Michael C. DeVito Collection, Richard Roy.)

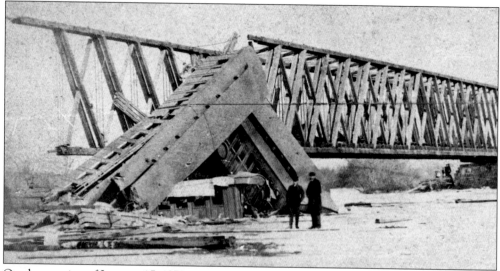

On the evening of January 15, 1878, a train carrying about 600 passengers was returning from a series of revival meetings conducted by evangelist Dwight Lyman Moody. The 10-car Connecticut Western train, pulled by two locomotives named *Salisbury* and *Tariffville*, left Hartford's Union Station at 9:20 p.m. Around 10:15 p.m., the train entered the uncovered Howe truss bridge over the Farmington River at Tariffville. (Courtesy of Richard Sanders Allen Collection, NSPCB Archives; William Allderige photograph.)

The Tariffville Bridge collapsed just as the locomotives reached the far side. The locomotives, a baggage car, and three passenger cars dropped into the frozen river. Some young men from New Hartford riding between the cars were killed when they were thrown beneath the wreck. The wreck claimed 13 lives and injured dozens. (Courtesy of Leroy Roberts Collection, Archives & Special Collections at the Thomas J. Dodd Research Center, University of Connecticut Libraries.)

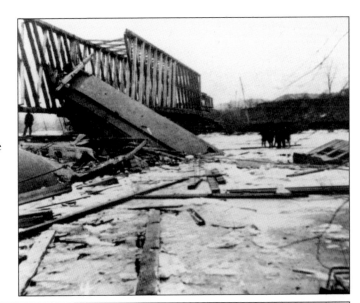

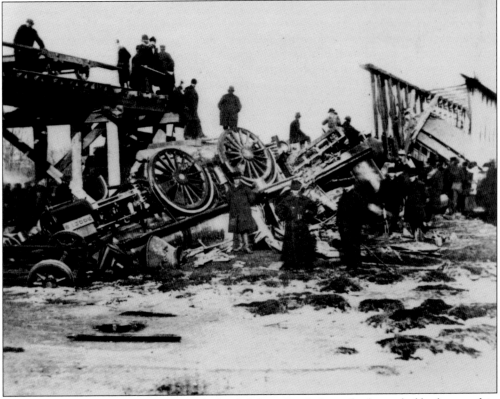

After the Tariffville Bridge collapsed, the *Salisbury* landed upside down, half submerged in the frozen ground at the river's edge. Engineer George Hatch, who was severely scalded by steam from the engine's broken boiler, died the following day. Relief trains carrying doctors and supplies were dispatched to the scene from Hartford and Winsted. (Courtesy of Leroy Roberts Collection, Archives & Special Collections at the Thomas J. Dodd Research Center, University of Connecticut Libraries.)

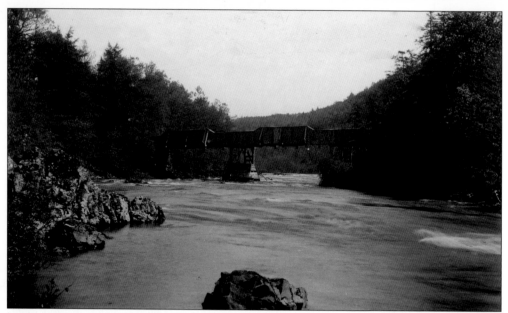

Downstream from the railroad bridge was a two-span pony truss highway bridge near the railroad depot at Tariffville. A freshet on June 10, 1892, created by heavy rain the previous day washed away every bridge between Tariffville and North Granby. A replacement bridge, built by the Berlin Bridge Company, was opened to traffic on July 20, 1892. (Courtesy of F.H. DeMars Collection, Margaret Giles.)

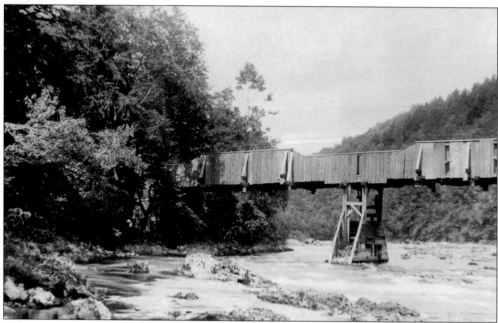

A July 4, 1890, *Hartford Courant* article stated that the wooden bridge near the Tariffville depot was found to be unsafe and was closed to traffic. Apparently, repairs were made because another article on March 17, 1892, noted that engineers found it to be unsafe and recommended that it be replaced. The bridge was finally replaced in July 1892 after the wooden bridge was washed away. (Courtesy of Michael C. DeVito Collection, Richard Roy.)

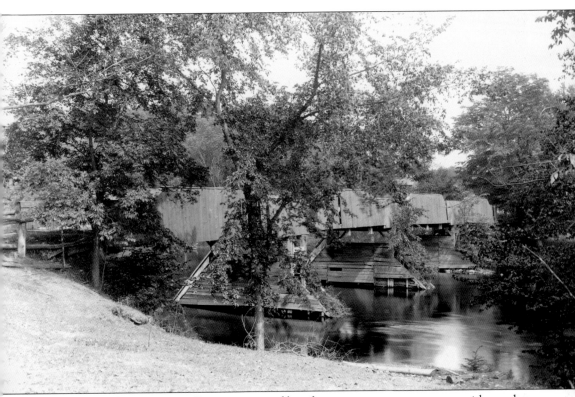

At Spoonville, the Farmington River was crossed by a four-span pony truss structure with wooden piers. On June 9, 1897, the *Hartford Courant* reported that a decision had been made to construct a new iron bridge and "not attempt to repair the old wooden structure which is rotten." The replacement bridge was one of the many structures lost during the August 1955 floods. In 1846, the Cowles Manufacturing Company started the country's first successful silver-plating industry. The popularity of its silver-plated spoons gave the community its name. (Courtesy of Michael C. DeVito Collection, Richard Roy.)

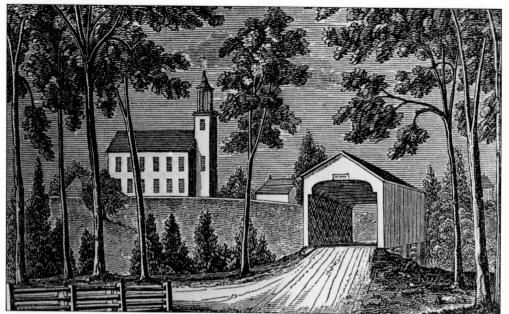

The first covered bridge upstream from the Farmington River's mouth was on Palisado Avenue at Windsor. This woodcut was originally published in John Warner Barber's *Connecticut Historical Collections* in 1836. It shows the first covered bridge at this location, which was built in 1833 to replace a 1793 wood trestle bridge. The Town lattice truss was washed away during a flood in May 1854. (Courtesy of Richard Sanders Allen Collection, NSPCB Archives.)

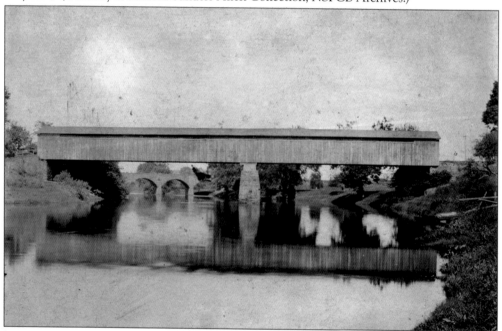

Fenton's Bridge over the Farmington River at Windsor was built in 1854 to replace the covered bridge destroyed by floodwaters earlier in the year. The stone arch railroad bridge in the background was built shortly after the Civil War and still stands today. It is not known what type of bridge carried the railroad before this stone one was constructed. (Courtesy of Windsor Historical Society.)

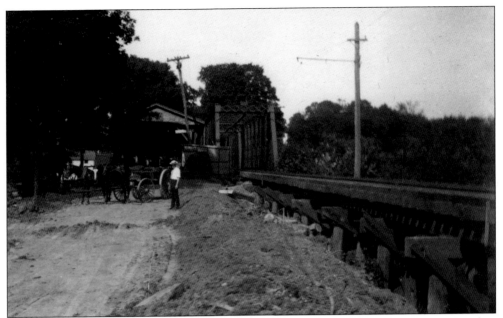

The iron bridge on the downstream side of Fenton's Bridge was built in 1904 when the Windsor Locks Traction Company constructed a line connecting Suffield and Windsor through Windsor Locks. The line was managed by the Hartford & Springfield Street Railway Company. In 1904, the fare from Hartford to Springfield, Massachusetts, through Windsor was 35¢. (Courtesy of Windsor Historical Society.)

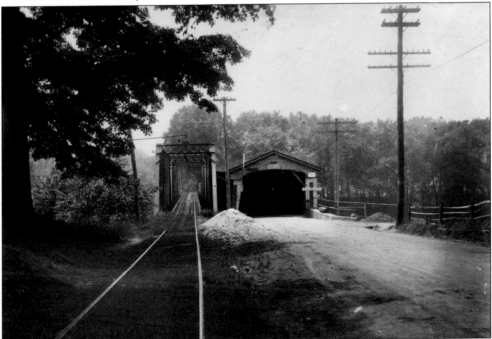

Fenton's Bridge, a two-span Howe truss structure, was razed on September 25, 1916, to make way for a new steel truss bridge to be constructed at that location. The iron bridge of the Hartford & Springfield Street Railway was removed in 1941. (Courtesy of Windsor Historical Society.)

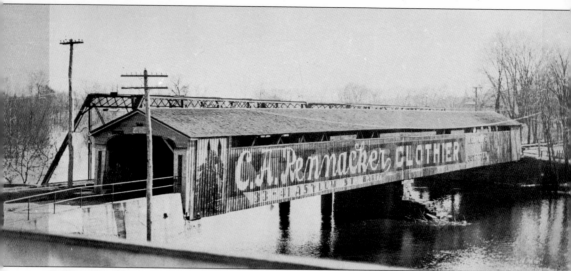

In the early 1900s, an advertisement for C.A. Rennacker, a clothier on Asylum Street in Hartford, was painted on the upstream side of Fenton's bridge at Windsor. A September 9, 1905, *Hartford Courant* article noted that the bridge "has been for years disfigured by a hideous sign, which stretches the full length of its western side." A motion to paint the bridge was made at the next town meeting but was not approved by the voters. (Courtesy of Richard Sanders Allen Collection, NSPCB Archives.)

# *Four*

# CENTRAL CONNECTICUT BRIDGES

Comstock Bridge crosses the Salmon River between Colchester and East Hampton. In 1915, a bill was introduced to the state legislature to transfer maintenance of the bridge from the towns of Colchester and Chatham (as East Hampton was known at the time) to Middlesex and New London Counties since the road was becoming a state trunk line. Ownership remained with the towns until the bridge was bypassed in the 1930s. (Courtesy of Andy Rebman.)

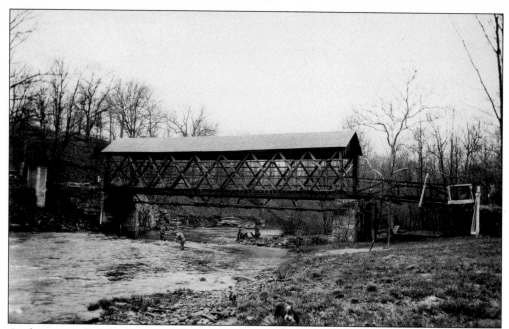

At the east end of the Comstock Bridge (on the right in this 1933 photograph) is a 35-foot-long pony truss span. A pony truss features an enclosed wooden truss without a roof or other bracing. This is the only wooden pony truss remaining in Connecticut. (Courtesy of Richard Sanders Allen Collection, NSPCB Archives.)

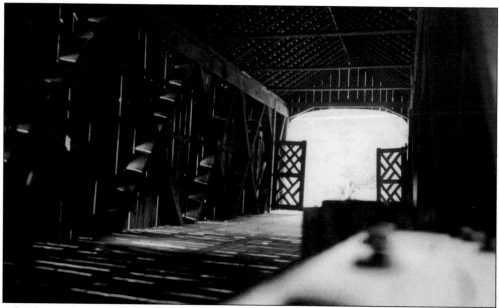

After being closed to traffic in the 1930s, Comstock Bridge was extensively renovated by the Civilian Conservation Corps, a federal program that put unemployed young men to work improving parks and forests. Wooden gates and new siding were added at that time. (Courtesy of NSPCB; Charles Rufus Harte photograph.)

These two pictures show the Comstock Bridge as it appeared during Michael DeVito's visit in September 1956. The first bridge at this location was built in 1791. The crossing was once part of the Colchester and Chatham Turnpike chartered by the Connecticut Legislature in October 1808. In 1873, the Town of Colchester voted that the bridge over Salmon River be rebuilt, and the Town of Chatham approved the project. The Howe truss covered bridge was built at a cost of $3,958.59. The bridge was dismantled and rebuilt in 2011. (Both, courtesy of Michael C. DeVito Collection, Richard Roy.)

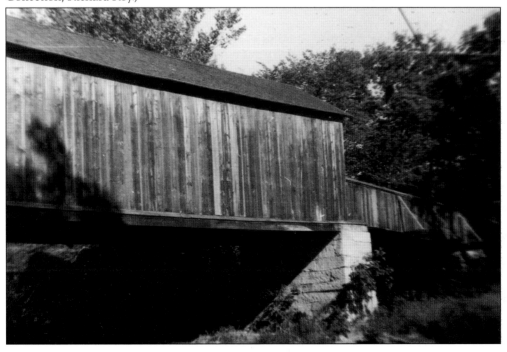

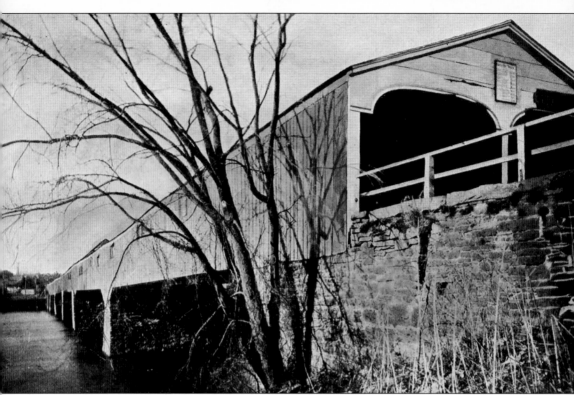

A *Gazetteer of the States of Connecticut and Rhode-Island*, published in 1819, described Hartford's new toll bridge: "The present bridge is constructed upon different principles from the former one, and is greatly improved from it. Its arches, of which there are six, of 150 feet each, are above the floor of the bridge, strengthened by strong braces, and well secured from the weather, the whole wood work being covered . . . There is a safe and convenient draw, upon the west side of the river, which obviates any serious obstruction to the navigation above this city . . . It has convenient sidewalks for the accommodation of foot passengers; is provided with what are termed 'dead lights,' upon each side, and sky lights upon the roof, at 20 feet distance, and a suitable number of lamps . . . This bridge, whether we consider its size, its strength, or the elegance of its structure, and general magnificence of its appearance, is surpassed by few in the United States." (Courtesy of Hartford National Corporation Records, Archives & Special Collections at the Thomas J. Dodd Research Center, University of Connecticut Libraries.)

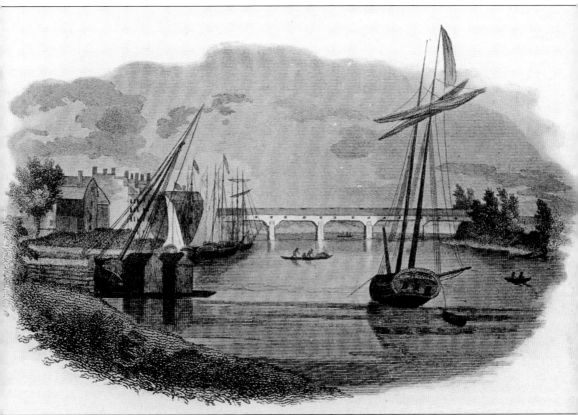

This view of the Hartford Toll Bridge over the Connecticut River, dated 1824, was engraved by Asaph Willard. When the new Hartford Toll Bridge was built in 1818, the piers of the previous bridge were raised four feet to reduce the potential of the bridge being carried off in a flood. An additional pier was added on the western end to support a draw span that was required to allow ships to navigate upstream. Even with that precaution, the *Daily Courant* of January 28, 1839, reported that "one of the most violent storms of wind and rain within our recollection" raised the river enough for the ice to carry off one of the spans near the East Hartford end. Traffic was rerouted to the toll bridge at Enfield until repairs could be made. (Courtesy of Hartford National Corporation Records, Archives & Special Collections at the Thomas J. Dodd Research Center, University of Connecticut Libraries.)

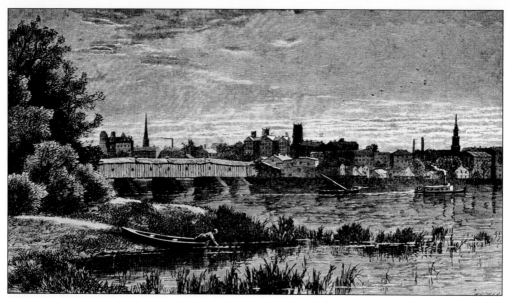

This engraving by noted illustrator J.D. Woodward shows the view towards downtown Hartford from the northeast. The steamboat *Charles H. Dexter* has passed the covered bridge and is heading toward Windsor Locks. By the mid-1800s, only shallow draft ships could navigate the Connecticut River north of Hartford. (Courtesy of Hartford National Corporation Records, Archives & Special Collections at the Thomas J. Dodd Research Center, University of Connecticut Libraries.)

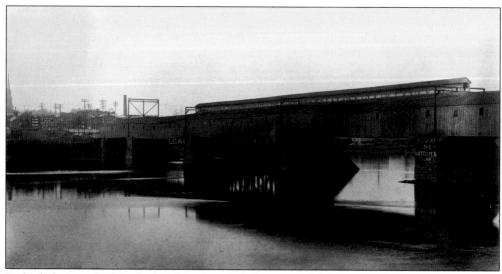

To let light into the Hartford Toll Bridge, skylights were added in a cupola over the two center spans. This picture was taken at a point downstream from the bridge, on the East Hartford side looking towards Hartford. (Courtesy of F.H. DeMars Collection, Margaret Giles.)

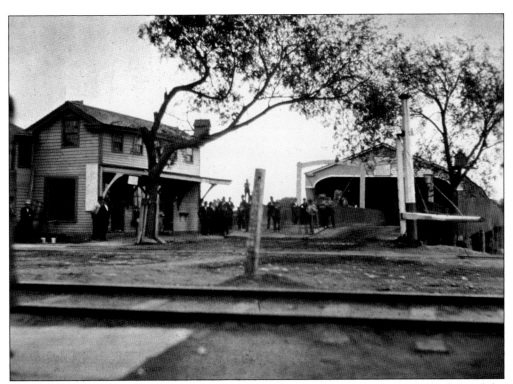

The tollhouse was on the Hartford side at the foot of Morgan Street between the bridge and the railroad tracks. There was a board showing the heights of the most extraordinary floods on the river at the tollhouse. The tollhouse was demolished in the summer of 1899 to make way for a new entrance to Riverside Park. (Courtesy of Connecticut Historical Society.)

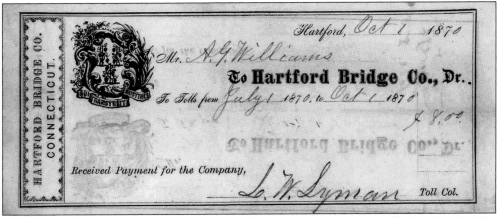

This receipt indicated that A.G. Williams paid $8 for his Hartford Bridge tolls from July 1, 1870, to October 1, 1870. The receipt is signed by L.W. Lyman, toll collector. Lyman was the eighth of fifteen toll collectors at the bridge. (Courtesy of Michael C. DeVito Collection, Richard Roy.)

**FARES OF THE BRIDGE.**

| | | d¢ |
|---|---|---|
| EACH MAN AND HORSE | | 4 |
| " FOOT PASSENGER | | 1 |
| " HORSE OR MULE LED OR DRIVEN | | 3 |
| " OX OR OTHER NEAT KINE LED OR DRIVEN | | 2 |
| " SHEEP, SWINE OR GOAT | | 1 |
| " CHAISE, CHAIR, SULKY OR GIG | | 8 |
| " CART OR WAGON DRAWN BY ONE HORSE | | 6¼ |
| " ONE HORSE BAROUCHE | | 8 |
| " CURRICLE WITH TWO HORSES & DRIVER WITH OR WITHOUT PASSENGERS | | 25 |
| " FOUR WHEEL PLEASURE CARRIAGE WITH TWO HORSES & DRIVER WITH OR WITHOUT PASSENGERS | | 25 |
| " FOUR WHEEL CARRIAGE WITH FOUR OR MORE HORSES | | 25 |
| " MAIL STAGE AND DRIVER WITH OR WITHOUT PASSENGERS | | 25 |
| " TWO HORSE PLEASURE SLEIGH & DRIVER WITH OR WITHOUT PASSENGERS | | 16 |
| " ONE HORSE PLEASURE SLEIGH & DRIVER WITH OR WITOUT PASSENGERS | | 8 |
| " SLED, SLEIGH, CART OR WAGON DRAWN BY TWO BEASTS LOADED OR EMPTY & DRIVER | | 12½ |
| " EXTRA BEAST | | 3 |

The toll for a man and horse was 4¢. Fees ranged from 1¢ for a pedestrian, sheep, swine, or goat up to 25¢ for four-wheeled carriages. The Hartford Bridge Company collected tolls on the bridge until September 11, 1889, when the legislature transferred the bridge to public ownership. The state paid 40 percent of the cost, and the remaining 60 percent was divided between Hartford, East Hartford, Glastonbury, Manchester, and South Windsor. (Both, courtesy of Michael C. DeVito Collection, Richard Roy.)

The Hartford and Wethersfield Horse Railroad Company and the East Hartford and Glastonbury Horse Railroad Company competed for the right to run their cars over the bridge. In May 1890, the Hartford company was awarded the rights to cross the bridge under the conditions that the cars were only powered by horses or mules and that they construct the tracks on the east side of the bridge to connect with the East Hartford company. The track was electrified two years later. (Courtesy of Richard Sanders Allen Collection, NSPCB Archives.)

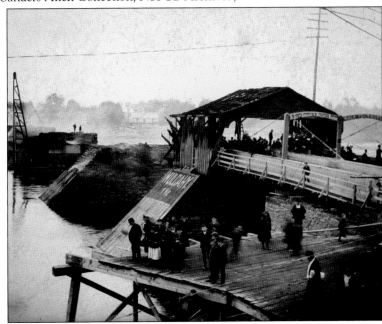

The Hartford Toll Bridge burned on May 17, 1895. The blaze started near the East Hartford end and quickly spread through the entire structure. The sign at the entrance reads: "To see Bargains in Mulcahy's Window, Walk your Horses." (Courtesy of Connecticut State Library.)

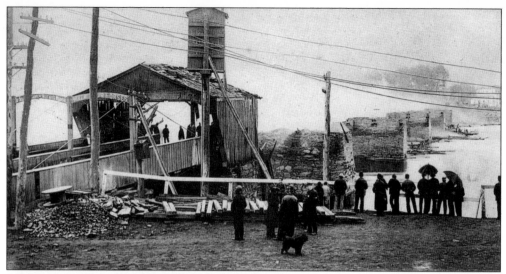

A hose cart and two horses from Hartford's Engine Company No. 3 responding to the fire were trapped inside the bridge when it collapsed into the river. The driver and fireman survived. When the fire was over, only the draw span and entrance on the Hartford side remained. (Courtesy of Todd Clark.)

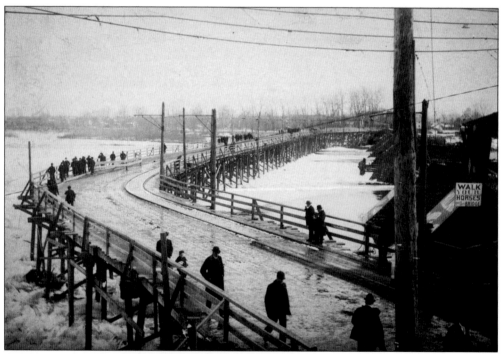

A temporary wooden bridge was constructed on the upstream side of the bridge immediately after the fire and was opened to traffic on June 8, 1895. Six months later, on December 23, 1895, floodwaters carried it away. A more substantial temporary bridge was constructed to carry vehicle and trolley traffic until the stone arch Bulkeley Bridge was opened in December 1907. (Courtesy of Connecticut Historical Society.)

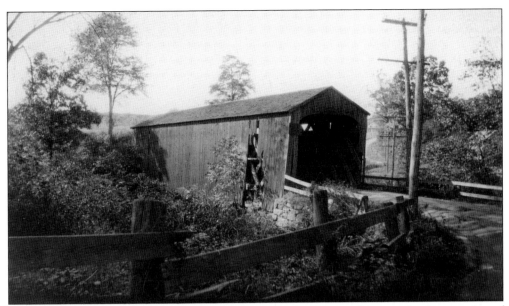

The Scantic River, or Osborn's Mill, Bridge crossed the Scantic River at the intersection of Cemetery, Woolam, Omelia, and Ellsworth Roads in East Windsor. It was supported by a Town lattice truss that was built in 1842. The dark, tightly boarded structure had almost square portals. In June 1928, voters approved funds to replace the covered bridge with an iron one. The bridge was soaked with oil and set afire in October 1928 after the new wider concrete-and-steel bridge was completed. (Courtesy of Andy Rebman.)

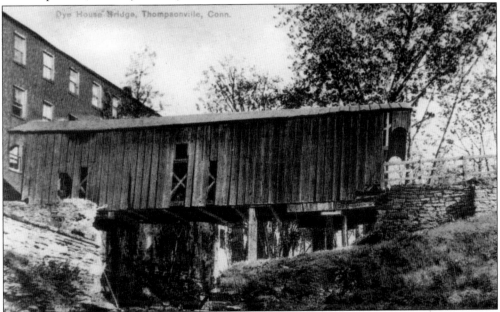

In 1844 and 1845, the Thompsonville Carpet Manufacturing Company expanded by adding a yarn mill and dye house. The dye house was located on the south side of the brook, necessitating a footbridge to get to and from the main part of the mill. Most of the mill buildings were lost in a fire in November 1889. The dye house was removed in 1905. The bridge remained until 1911. (Courtesy of Richard Sanders Allen Collection, NSPCB Archives.)

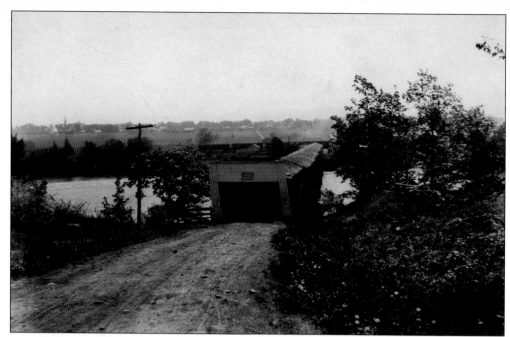

A privately owned toll bridge over the Connecticut River and Enfield Canal was built in 1826 to connect Enfield and Suffield. The six-span Town truss was 1,000 feet long. At the canal end, there were steps to get to and from the canal's towpath. (Courtesy of Richard Sanders Allen Collection, NSPCB Archives.)

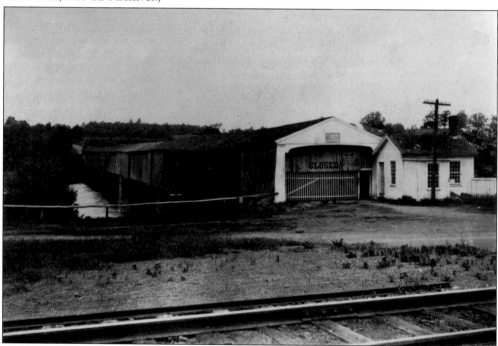

At a joint meeting of the Enfield and Suffield selectmen in April 1896, the Enfield-Suffield Toll Bridge was declared unsafe and was closed. (Courtesy of Richard Sanders Allen Collection, NSPCB Archives.)

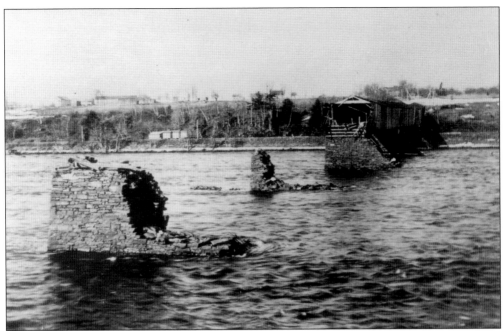

Hosea Keach, Enfield Bridge station agent and watchman, went inside to check on it during the February 1900 freshet. The rushing water carried away three spans, including the one Keach was standing on. Downstream, at Warehouse Point, a group of men on the iron railroad bridge tossed a rope down to him as the wooden structure passed by. Keach caught the rope and was pulled to safety. (Courtesy of Richard Sanders Allen Collection, NSPCB Archives.)

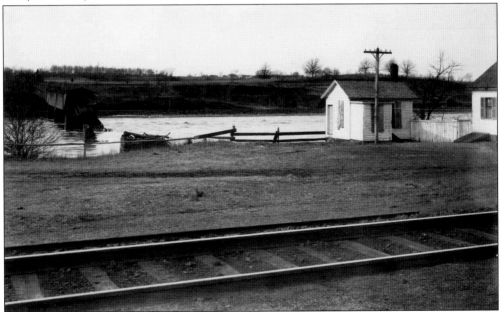

On February 15, 1900, a freshet washed away three of the Enfield-Suffield Bridge's six spans. Around 1903, the Southern New England Telephone Company bought the site and dynamited the remains of the bridge to use the piers for carrying telephone wires across the river. (Courtesy of Michael C. DeVito Collection, Richard Roy.)

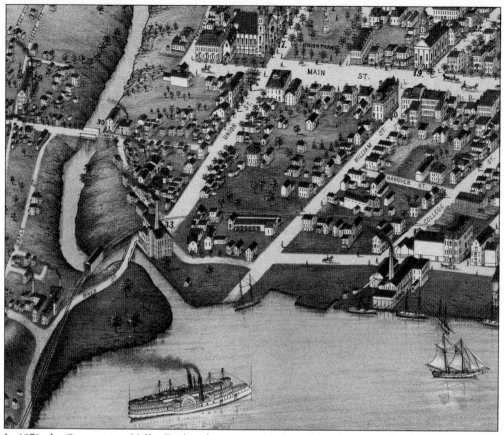

In 1871, the Connecticut Valley Railroad constructed a line along the west side of the Connecticut River from Hartford to Old Saybrook. The line included at least five covered bridges. Two of those bridges are shown on O.H. Bailey's 1877 panoramic map of Middletown. This one was on the south side of town over Sumner Brook. (Courtesy of the Map and Geographic Information Center [MAGIC], University of Connecticut Libraries.)

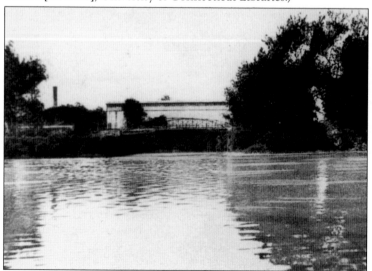

The Connecticut Valley Railroad bridge at the southern edge of Middletown was adjacent to a crossing on River Street that has since been abandoned. The railroad bridge was replaced in the first decade of the 1900s. (Courtesy of Michael C. DeVito Collection, Richard Roy.)

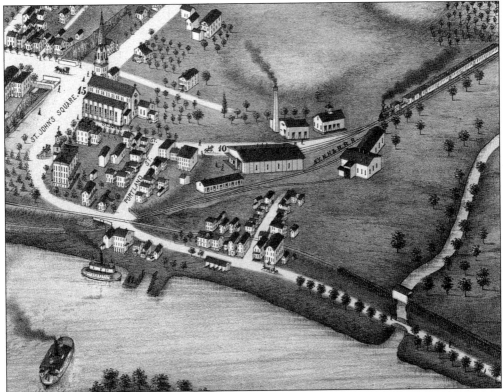

Bailey's 1877 map of Middletown also showed a covered bridge near the mouth of the Mattabesett (or Little) River at the north end of Middletown. On April 30, 1911, R.R. Clifford, a railroad brakeman, was killed when he struck the timbers of the bridge as he was riding on one of the freight cars. (Courtesy of the Map and Geographic Information Center [MAGIC], University of Connecticut Libraries.)

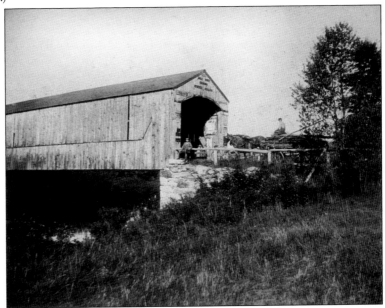

The location of the bridge in this 1890s photograph is not yet known. It may have crossed the Naugatuck River. (Courtesy of Connecticut Historical Society.)

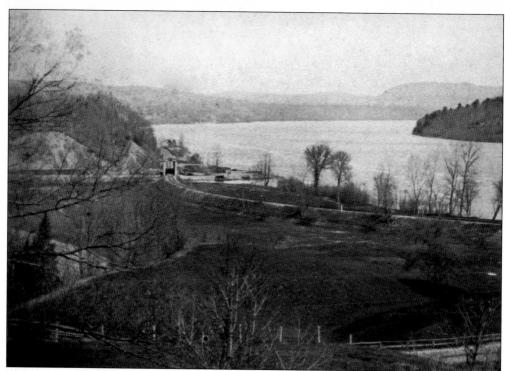

The Connecticut Valley Railroad built a covered bridge just north of the depot in the Higganum section of Haddam. The wooden bridges on this line were built of native oak by A.D. Briggs and Company of Springfield, Massachusetts, a subcontractor to Dillon and Clyde. The single-span bridge at Higganum Cove was replaced with a two-span steel bridge in 1903. (Above, courtesy of Connecticut Historical Society; below, courtesy of Geography and Map Division, Library of Congress.)

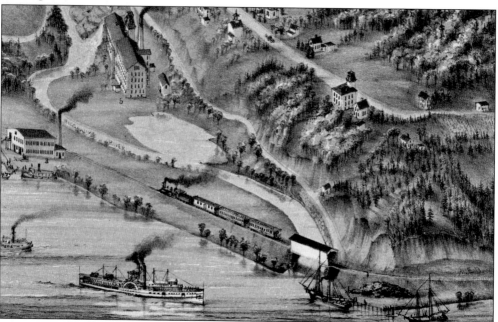

# *Five*

# SOUTHWESTERN CONNECTICUT BRIDGES

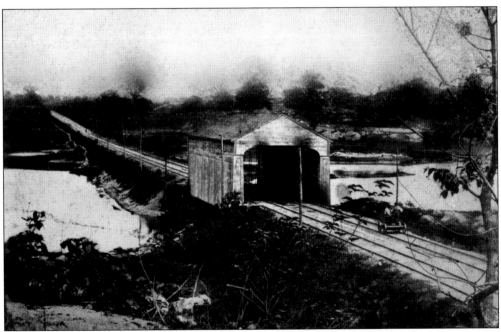

This double-track Howe truss bridge was built over Indian Harbor in Greenwich in 1848 for the New York & New Haven (NY&NH) Railroad. Located in the southwest corner of the state, it was the westernmost of Connecticut's covered bridges. More than half a dozen other covered bridges were built along the railroad in Southwestern Connecticut. This one was replaced by a wood pile bridge in 1876. The photograph was taken about 1859. (Courtesy of Christine Ellsworth Collection, NSPCB Archives.)

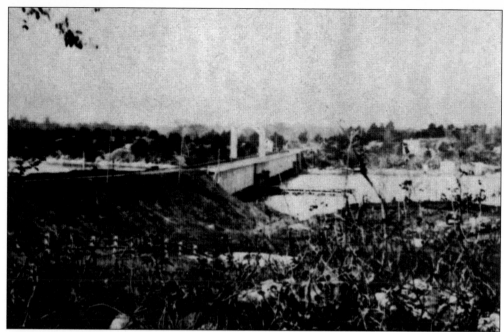

On October 14, 1865, a fire destroyed the western spans of the New York & New Haven Railroad bridge over the Mianus River at Cos Cob. The remainder of the bridge was saved by the bridge tender who opened the draw span, causing a break that the fire could not cross. The burned segment was replaced with an iron structure. On April 25, 1877, the remaining wooden structure, including the draw span, burned. An editorial in the April 26, 1877, *New York Times* commented that "the traveling public will be glad that the patched structure no longer threatens life and limb." A trestle containing 168 piles was built by 200 men in five days to replace the burned portion. It took an additional 12 days for a crew of 40 to build the 158-foot draw span. (Courtesy of Richard Sanders Allen Collection, NSPCB Archives.)

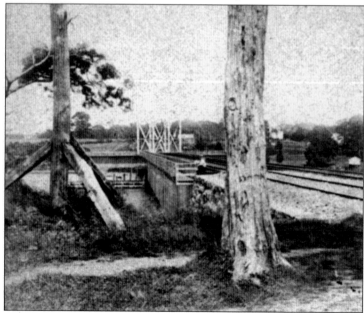

This may also be the New York & New Haven Railroad bridge at Cos Cob. Note the open draw span in the background. (Courtesy of Todd Clark.)

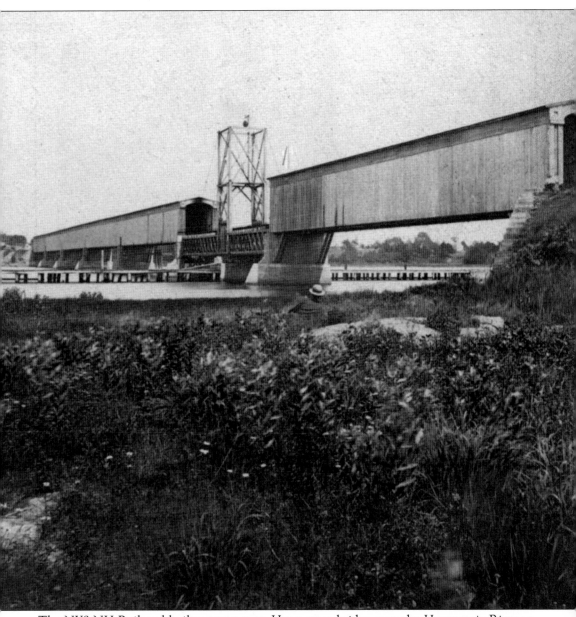

The NY&NH Railroad built a seven-span Howe truss bridge over the Housatonic River at Devon between Stratford and Milford. This structure was completed in September 1848 and was replaced on January 10, 1872, by a cast-iron Whipple truss. The seven-covered Howe truss spans were 1,293 feet long with a draw of 134 feet. It was the longest covered bridge ever built in the state of Connecticut. On September 15, 1849, a Naugatuck Railroad passenger train and a NY&NH passenger train collided at the east entrance to the bridge and damaged some timbers, which were repaired the next day. On September 9, 1852, a New York-bound NY&NH passenger train derailed due to a misplaced switch and ran into the bridge, causing the engine, tender, and the first 125-foot-long section of the bridge to fall into the river. Fortunately, the passenger cars did not follow, so the engineer and fireman were able to jump clear without injury. (Courtesy of Todd Clark.)

The first Fair Haven bridge was a single-track Howe deck truss structure built by the New Haven & New London Railroad around 1849. It was about 1,000 feet long and crossed the Quinnipiac River north of the present East Grand Avenue highway bridge. The railroad became part of the Shore Line Railway in 1864 and, eventually, one of the New Haven lines. (Courtesy of Leroy Roberts Collection, Archives & Special Collections at the Thomas J. Dodd Research Center, University of Connecticut Libraries.)

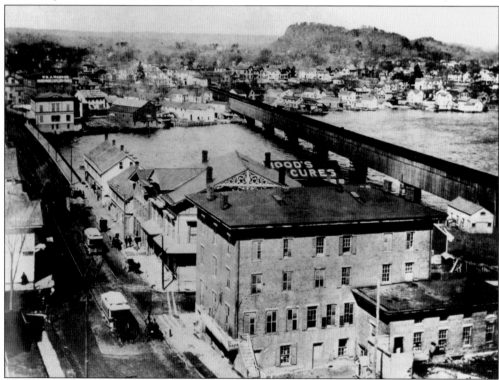

This photograph, taken in the 1860s, shows East Grand Avenue on the left and the Fair Haven railroad bridge on the right. East Rock can be seen off to the right in the background. The railroad bridge was rebuilt in 1874 and abandoned in 1894 when the line was rerouted and a new structure was built farther upstream. (Courtesy of Leroy Roberts Collection, Archives & Special Collections at the Thomas J. Dodd Research Center, University of Connecticut Libraries.)

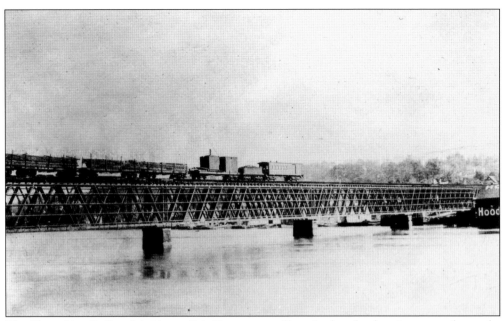

The Shore Line Railway's bridge at Fair Haven was still perfectly safe when it was razed to make way for a new double-track structure. The Howe trusses supporting the rails were clearly visible once the covering was removed. In 1893 and 1894, a four-mile-long segment of the Shore Line was rerouted to the east and north of this location. Moving the line required the railroad to bore a tunnel over 500 feet long through the rock under East Grand Avenue. As many as 300 men worked night and day to complete the project. The new route also eliminated dangerous grade crossings along the former route. (Both, courtesy of Richard Sanders Allen Collection, NSPCB Archives.)

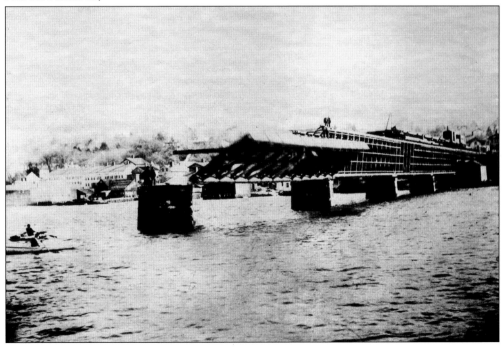

The first New York & New Haven Railroad covered bridge over the Wepawaug River at Milford was built in 1848 as a single-track structure about 80 feet long. It was either replaced or rebuilt in the late 1850s, when the line was double tracked and appears to have been replaced with another wooden structure of about the same length. (Courtesy of Michael C. DeVito Collection, Richard Roy.)

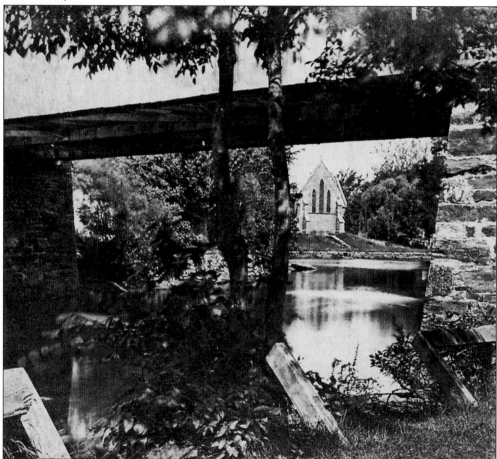

The bridge in this stereo view is probably the second Wepawaug River railroad bridge at Milford. The bridge was built in the 1850s and remained in service until 1878 when it was replaced with an iron pin-and-link bridge. If the location is correct, then the building in the background is St. Peter's Episcopal Church on River Street in Milford. (Courtesy of Charlie Dunn Collection.)

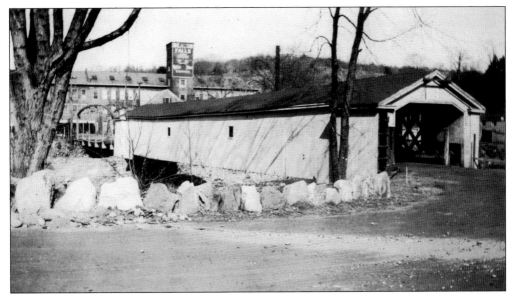

In 1835, the towns of Oxford and Bethany built an open wooden bridge over the Naugatuck River, about 300 feet south of the present Depot Street crossing at Beacon Falls. That bridge was lost during a flood in 1855. The following year, the American Hard Rubber Company, the leading industry in town, built this covered bridge at the location of the present crossing on Depot Street. (Courtesy of Michael C. DeVito Collection, Richard Roy; H.H. Mardoian photograph.)

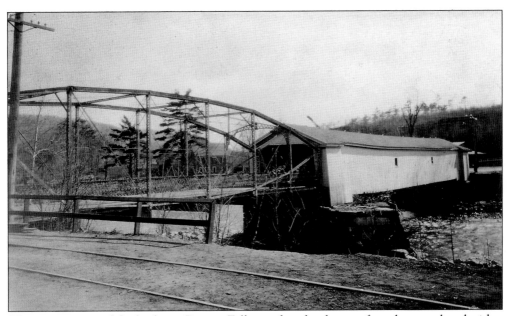

The eastern span of the bridge at Beacon Falls was found to be unsafe and was replaced with a steel span in 1892. (Courtesy of Michael Krenesky.)

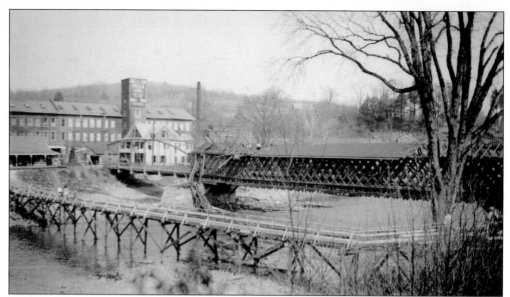

In 1860, the American Hard Rubber Company, which built the bridge at Beacon Falls, moved to Long Island, New York. Its property at Beacon Falls became part of the Home Woolen Company. In October 1865, the Home Woolen Company sold the bridge to the town of Bethany. In July 1871, ownership of the bridge was transferred to the newly incorporated town of Beacon Falls. (Courtesy of Michael C. DeVito Collection, Richard Roy; H.H. Mardoian photograph.)

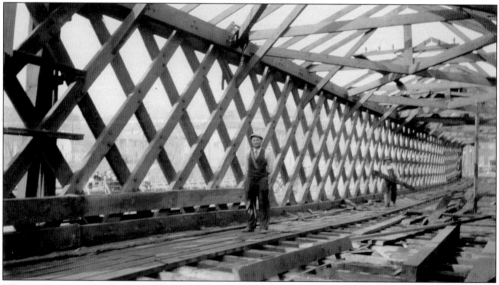

These photographs showing the demolition of the bridge at Beacon Falls were taken by H.H. Mardoian, who was the construction inspector for the project. In January 1935, the state highway department awarded a contract for construction of a steel truss bridge at Beacon Falls. Construction started in the spring. (Courtesy of Michael C. DeVito Collection, Richard Roy; H.H. Mardoian photograph.)

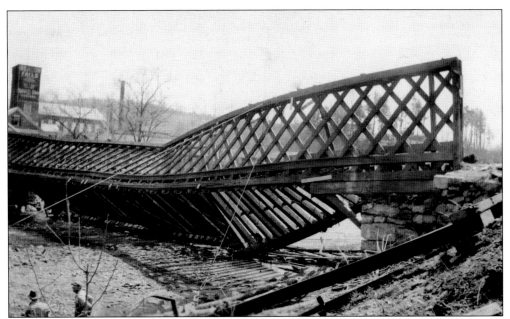

Even with the extra strain of having one side removed, the remaining Town lattice truss is still intact. (Courtesy of Michael C. DeVito Collection, Richard Roy; H.H. Mardoian photograph.)

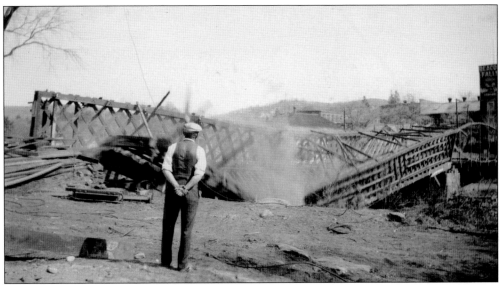

A new bridge over the Naugatuck River at Beacon Falls was dedicated on October 26, 1935, in a ceremony attended by an estimated 5,000 local citizens. After a parade, Beatrice Schmitz, daughter of Selectman Theodore Schmitz, cut the ribbon to open the roadway. (Courtesy of Michael C. DeVito Collection, Richard Roy; H.H. Mardoian photograph.)

O.H. Bailey's 1879 panoramic map of Seymour shows two covered bridges over the Naugatuck River. The Naugatuck Railroad bridge on the left crossed over into the northern end of the business district. On the right is the Bank Street Bridge. Many of the homes and businesses along the riverbank were destroyed or badly damaged during the August 1955 flood. The river's east bank,

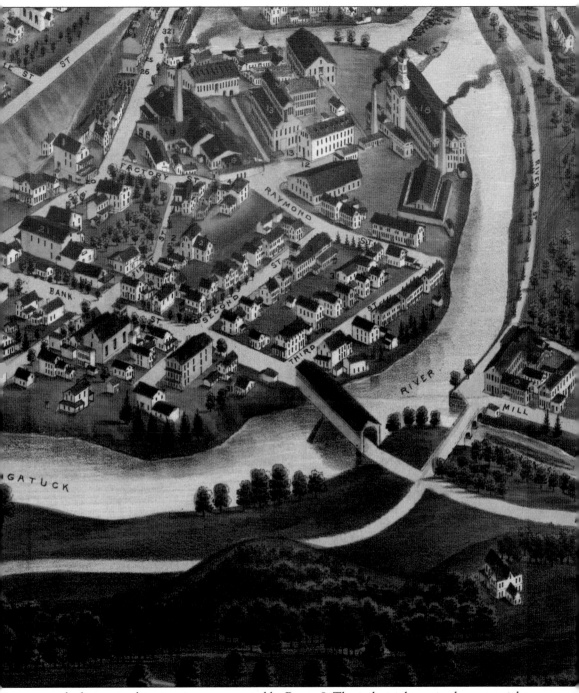

towards the top in this view, is now occupied by Route 8. The industrial area in the upper right corner is now a parking lot. (Courtesy of the Map and Geographic Information Center [MAGIC], University of Connecticut Libraries.)

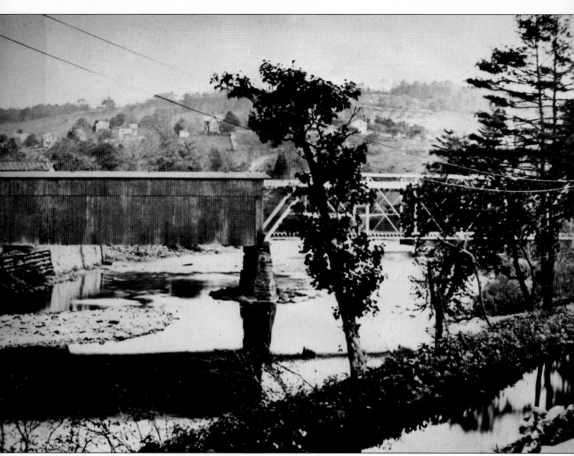

The Naugatuck Railroad bridge was originally built in 1849. It was rebuilt by Stone and Harris of Springfield, Massachusetts, in 1853 and 1854 at a cost of $4,538.66 after being destroyed by floodwaters on November 13, 1853. One span was replaced in 1878 to 1879, and the other was replaced around 1896. The 1879 *Railroad Commissioners' Report* noted that the oldest span of the bridge at Seymour was to be replaced with an iron span built by the Keystone Bridge Company. The new iron span was tested on January 31, 1879, and found to be acceptable. (Courtesy of Seymour Historical Society.)

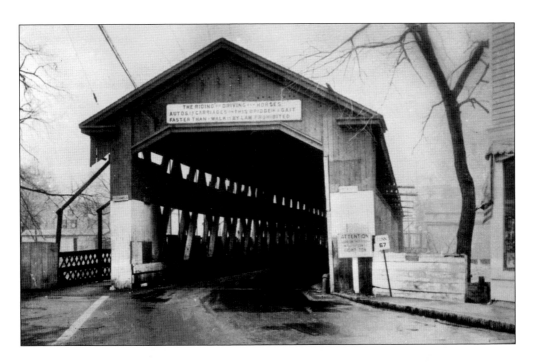

The covered bridge over the Naugatuck River on Bank Street in Seymour was a two-span Howe truss constructed in 1856. Note the pedestrian walkway on the left side. That was a common feature on bridges near village centers. A concrete bridge replaced the Bank Street Bridge in 1936. (Above, courtesy of Michael C. DeVito Collection, Richard Roy; below, courtesy of Seymour Historical Society.)

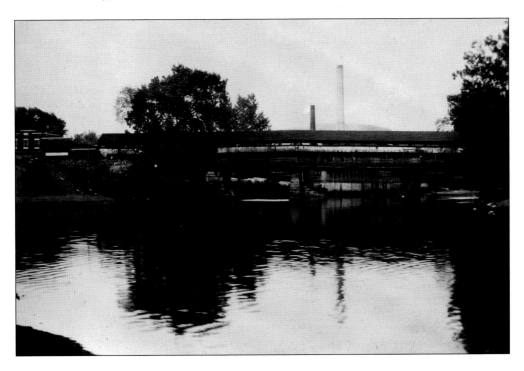

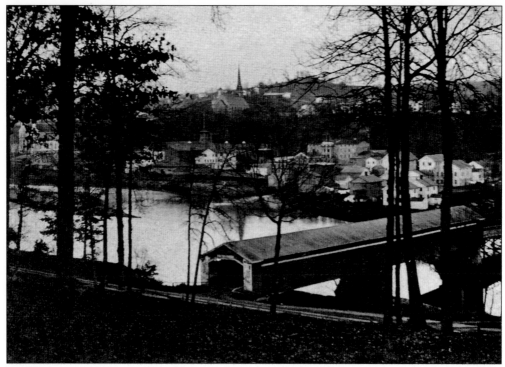

The first covered bridge over the Naugatuck River on Bridge Street in Ansonia was built in 1870. At the time, the area was part of the town of Derby. After a flood carried it away in 1873, it was replaced with the bridge shown here from the western side looking towards Ansonia. (Courtesy of Todd Clark.)

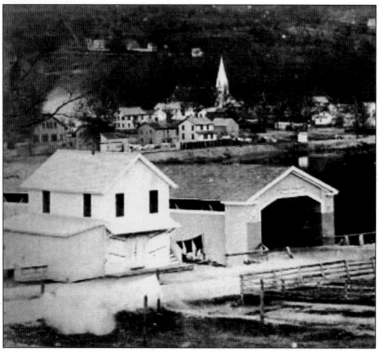

On April 6, 1892, Ansonia's covered bridge caught fire and was completely destroyed. The fire was thought to have been started by a cigar or sparks from a passing train. High winds carried the flames through the bridge, making for a complete loss. It was replaced with an iron bridge. (Courtesy of John Vagnini.)

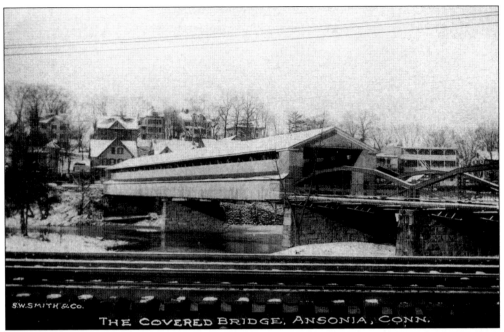

Ansonia's covered bridge was a toll bridge until the Towns of Derby and Shelton bought it in 1875. A walkway was built on the bridge's south side in 1878. Bailey's 1875 map of Ansonia shows a trestle bridge at the location of the two metal spans at the eastern end. The tracks of the New Haven & Derby Railroad and the Naugatuck Railroad are in the foreground. (Courtesy of Richard Sanders Allen Collection, NSPCB Archives.)

The Naugatuck Railroad was constructed in the Derby area in 1849. The first bridge at the mouth of the Naugatuck River was probably built at that time. It was replaced with covered bridges in the early 1870s and again around 1880. This bird's-eye view of Derby, Shelton, and East Derby was published in 1898 by Landis and Hughes. (Courtesy of Geography and Map Division, Library of Congress.)

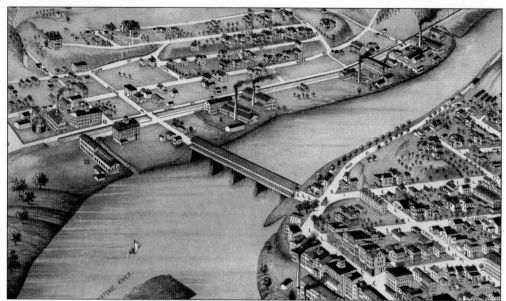

The Huntington Bridge was a four-span structure over the Housatonic River connecting the towns of Derby and Shelton at Birmingham. It was replaced with an iron bridge in 1891. The iron bridge carried both the roadway and a trolley line. It vibrated so much when the trolley crossed that it was often reported as unsafe. As a result, it was replaced with a new bridge in 1918. (Courtesy of Geography and Map Division, Library of Congress.)

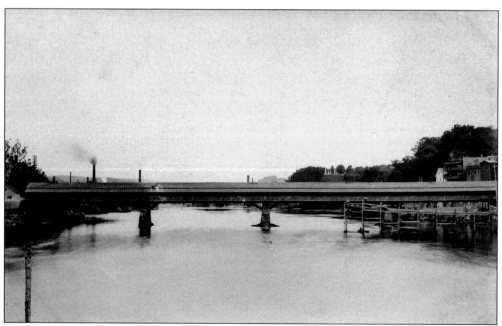

The Huntington Bridge connected Huntington (now Shelton) with Birmingham (the section of Derby between the Housatonic and Naugatuck Rivers). It was originally built as a toll bridge to replace an earlier one washed out in a flood in 1857. In 1871, a pedestrian walkway was built along the outside of the south side of the bridge. In 1872, Huntington and Birmingham purchased the bridge and removed the tolls. (Courtesy of Todd Clark.)

# *Six*

# EASTERN CONNECTICUT BRIDGES

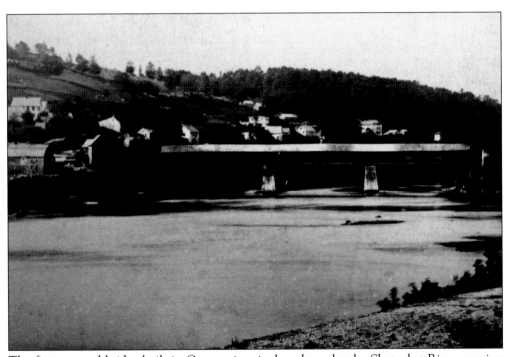

The first covered bridge built in Connecticut is thought to be the Shetucket River crossing constructed by the Norwich & Preston Bridge Company in 1816. On March 6, 1823, floodwaters carried it half a mile downstream, where it broke up on the falls near the river's mouth. This view shows the replacement bridge constructed shortly afterwards. (Courtesy of Christine Ellsworth Collection, NSPCB Archives.)

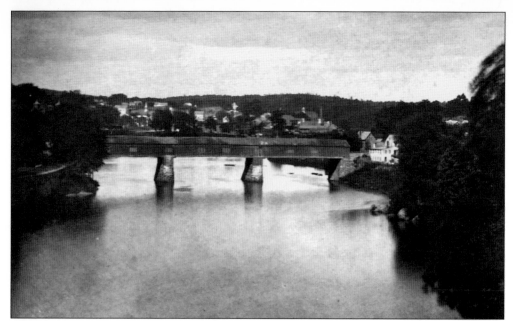

The first Preston Toll Bridge cost $10,000 to construct. Since the flood that swept the bridge downstream in 1823 left the piers intact, it only cost $5,000 to construct the replacement bridge. Minutes from the July 24, 1869, Norwich town meeting stated that voters approved a proposal to immediately replace the "rather dilapidated" toll bridge with an iron one. A contract to build the iron bridge was signed on August 28, 1869. (Courtesy of Todd Clark.)

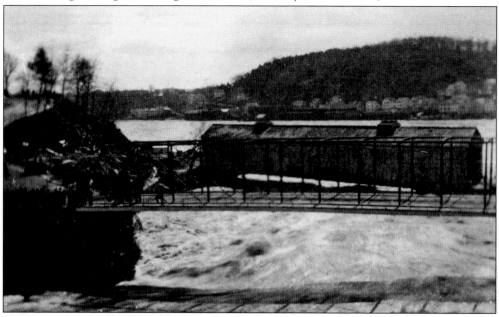

Sand carried down the Shetucket River during severe flooding in 1841 created a sandbar in the Thames River, disrupting steamboat traffic to the wharf at the railroad depot. Consequently, the Norwich & Worcester Railroad constructed a line from the depot southward for seven miles along the Thames to Allyn Point. Immediately south of the depot was the lofty bridge over the Shetucket. (Courtesy of Michael C. DeVito Collection, Richard Roy.)

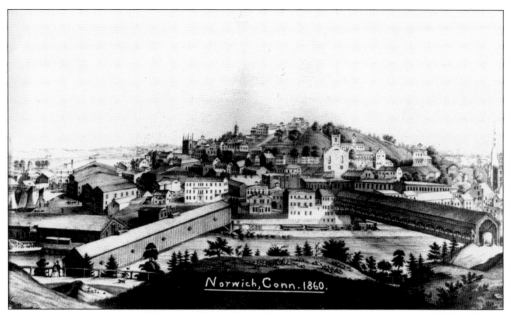

This drawing, dated 1860, depicts Norwich from the south, showing the two covered bridges at the mouth of the Shetucket River. The covered bridge on the left was constructed by the Norwich & Worcester Railroad to extend the railroad line south towards Allyn Point. The bridge on the right connected the Laurel Hill section of Norwich with the downtown area near the present location of Water Street. (Courtesy of William Shannon.)

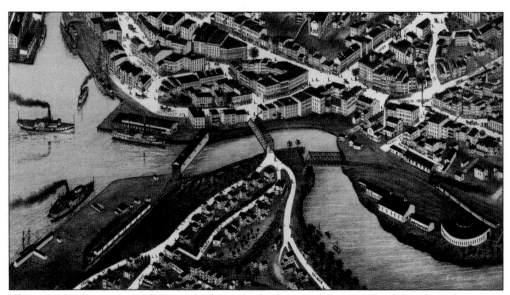

This 1876 bird's-eye view of Norwich shows the bridges near the mouth of the Shetucket River. The railroad bridge on the left was removed in 1877 after being replaced by the iron bridge on the right. To relocate the line, the railroad bored a tunnel through Laurel Hill. The Laurel Hill Bridge (center) was privately owned from 1853 until 1860, when it was turned over to the town. (Courtesy of the Map and Geographic Information Center [MAGIC], University of Connecticut Libraries.)

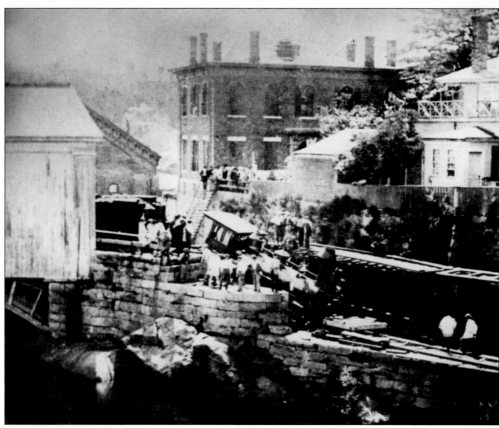

On July 18, 1869, Norwich & Worcester Railroad engine No. 15 *Thames* went off the track at the northern end of the swing bridge over the mouth of the Shetucket River while pulling a load of coal cars from Allyn Point. A spur track went under the swing bridge to the dock and freight house. The bridge would swing aside to allow trains to access the dock. (Above, courtesy of Elmer F. Farnham Railroad Collection, Archives & Special Collections at the Thomas J. Dodd Research Center, University of Connecticut Libraries; below, courtesy of Todd Clark.)

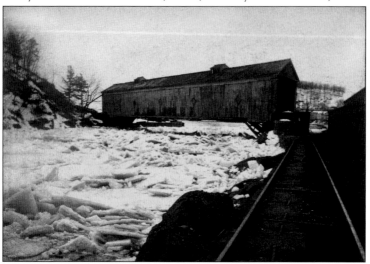

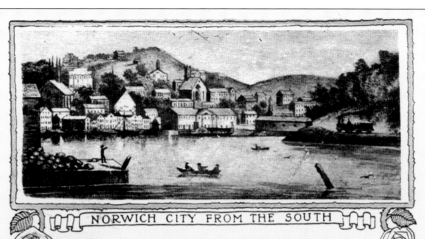

NORWICH CITY FROM THE SOUTH

**N**orwich City is singularly romantic in it's situation. Its very streets are declevities, and its buildings are in tiers, one above another It is built just upon the point of land where the Shetucket meets the Thames: its lower streets have either been won from the water, or blasted out of the rock. The first view of it from the river below is very striking; it appears and disappears in the winding of the river as if a drop curtain had shut it out from view. As you approach it by water at night, lights from the houses high up the hill seem to be suspended in the air. Norwich City has now seven churches.

*FROM HISTORY OF NORWICH 1845*

COPYRIGHT 1905 BY WILDES & CO. MANSFIELD CENTER, CONN.

The text and image on this card were taken from Frances Manwaring Caulkins's 1845 *History of Norwich*. The covered railroad bridge at the mouth of the Shetucket River can be seen near the right side, connecting Laurel Hill with downtown Norwich. The Thames River is in the foreground. (Courtesy of William Shannon.)

The Norwich & Worcester Railroad's covered bridge over the Shetucket River near Taft Station is at the far left edge of this photograph. The boxcar in the center is on a spur line to Ponema Mills in Taftville. (Courtesy of Elmer F. Farnham Railroad Collection, Archives & Special Collections at the Thomas J. Dodd Research Center, University of Connecticut Libraries.)

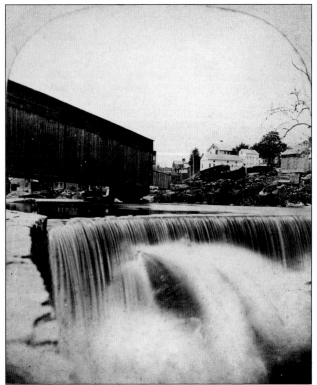

The New London, Willimantic & Springfield Railroad built this bridge over the Yantic River at Norwich Falls around 1848. The bridge had two spans—one was a fully covered Howe truss and the other was a covered pony truss. The bridge burned in the spring of 1875 and was replaced with an iron Whipple truss that was opened on August 20, 1875. (Courtesy of Todd Clark.)

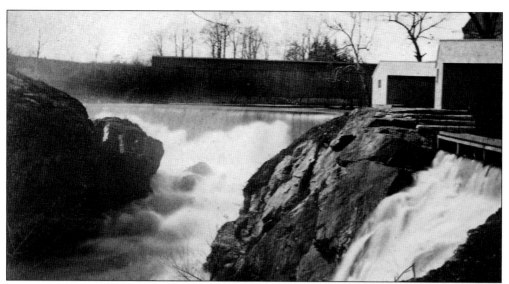

The New London, Willimantic & Springfield Railroad later became the New London Northern Railroad and, eventually, the Central Vermont Railway. This bridge over the Yantic River at Norwich Falls was one of three covered bridges on this line in the Yantic area. On December 2, 1891, the next covered bridge to the north was ignited by a spark from a passing locomotive and burned. A temporary bridge was expected to be in place the next day. A permanent iron bridge was built later. The third bridge, northwest of Yantic, was replaced around 1910. All three were probably Howe truss structures. (Above, courtesy of Todd Clark; below, courtesy of Christine Ellsworth Collection, NSPCB Archives.)

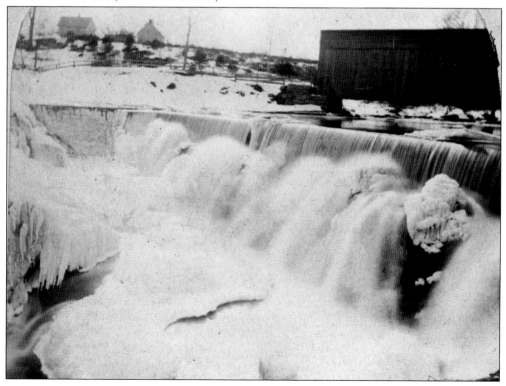

Around 1848, a covered bridge (far right) that was one rod wide, 16.5 feet tall, and about 50 feet long was built over the Willimantic River at South Willington so that residents of Tolland could get to the railroad depot (left). The bridge was replaced in 1908, with the towns of Tolland and Willington sharing the costs. This view was taken from a point northwest of the bridge. (Courtesy of Michael C. DeVito Collection, Richard Roy.)

The iron railroad bridge at South Willington (far left) replaced a covered bridge that burned during the evening of January 26, 1893. The fire was discovered around 6:00 p.m. and progressed so swiftly that the bridge could not be saved. The covered highway bridge is in the center of this view. (Courtesy of Leroy Roberts Collection, Archives & Special Collections at the Thomas J. Dodd Research Center, University of Connecticut Libraries.)

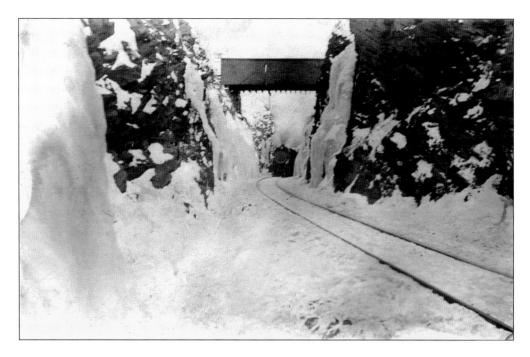

A pony truss bridge carried Notch Road over the New York & New England Railroad at Bolton Notch. The sidewalls were 10 feet high, although it is not known if it ever had a roof. Newspaper articles at the time of its replacement suggest that it was built when the railroad was constructed in 1849. However, the obituary of Henry B. Bragg, Civil War veteran of Bolton born in 1847, noted that after the war, he was the gate tender at the Bolton Notch railroad crossing for many years before the bridge was built. The Bolton Notch bridge was replaced in 1955. (Above, courtesy of Leroy Roberts Collection, Archives & Special Collections at the Thomas J. Dodd Research Center, University of Connecticut Libraries; below, courtesy of Richard Roy.)

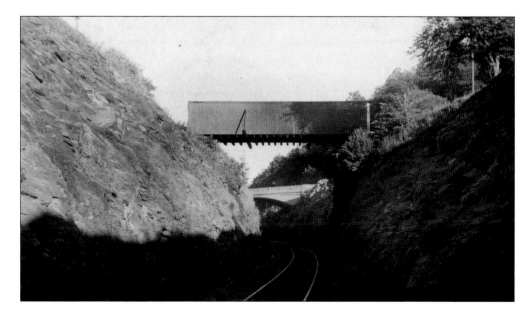

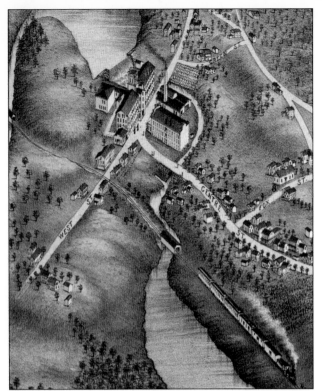

The New London Northern Railroad had two covered bridges at the western edge of Stafford Springs, which are shown on O.H. Bailey's 1878 map of Stafford Springs. The western bridge is only partially shown on the map. The bridge near the center of this image was replaced with an iron bridge in the spring of 1899. (Courtesy of the Map and Geographic Information Center [MAGIC], University of Connecticut Libraries.)

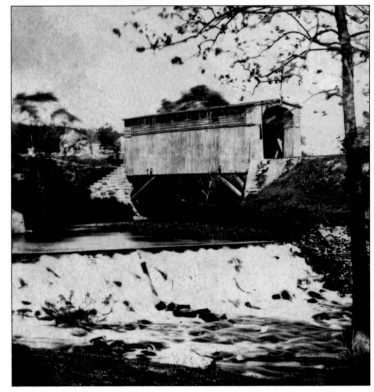

This unidentified railroad bridge may have been in the Windham or Norwich area. (Courtesy of Christine Ellsworth Collection, NSPCB Archives.)

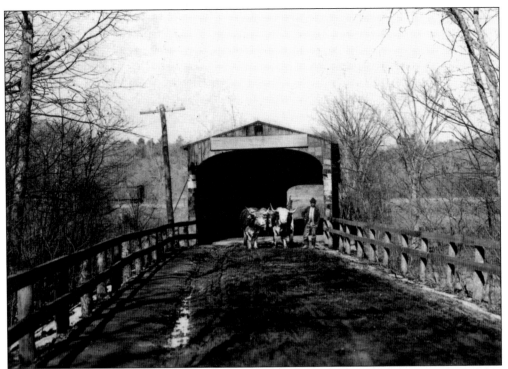

The South Windham Bridge crossed the Shetucket River just northeast of the village on Windham Center Road. Over its rounded portal was a sign reminding travelers, "The riding or driving any Horses, Teams of Carriages on this Bridge in a Gait faster than a Walk is by Law prohibited." The picture shows a pair of oxen owned by the Smith Winchester Machine Company returning from the freight station on the east side of the river. (Both, courtesy of Michael C. DeVito Collection, Richard Roy.)

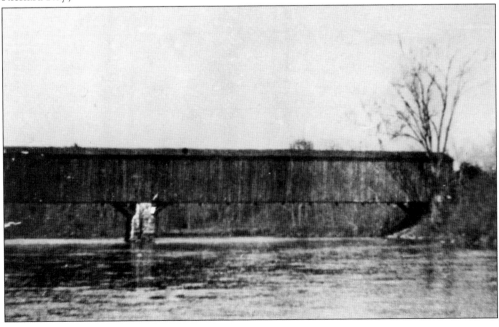

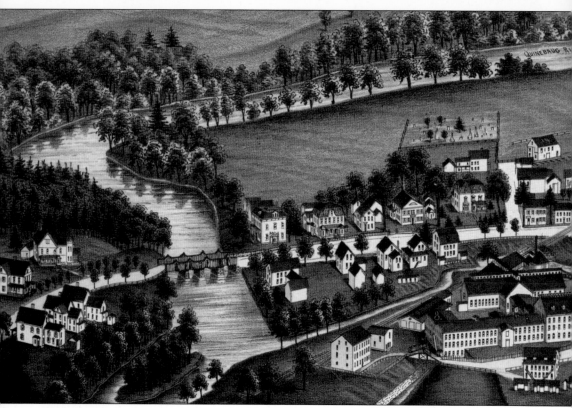

An interesting pony truss bridge carried Main Street over the Quinebaug River about 400 feet north of the present crossing at Jewett City. The four-span king post bridge is shown on L.R. Burleigh's 1889 map of Jewett City. The Norwich & Worcester Railroad had a covered bridge that would have been slightly beyond the lower left corner of the map. In the spring of 1871, the railroad commissioners found the bridge unfit for continued use and ordered it replaced. The 1872 commissioners' report stated that the replacement bridge had been built as ordered. (Courtesy of Geography and Map Division, Library of Congress.)

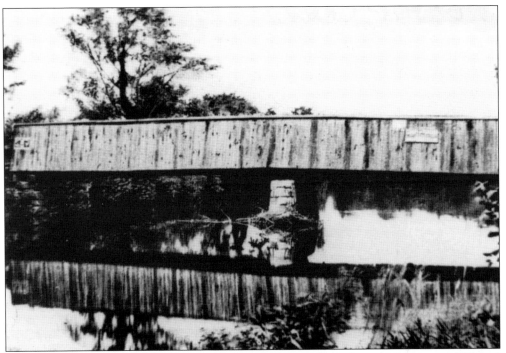

Corey's Bridge was a pony truss structure crossing the Moosup River between Moosup and Central Village. At one time, the bridge carried an advertisement on the right span for C.E. Barber's Hardware store in Central Village. (Courtesy of Richard Roy.)

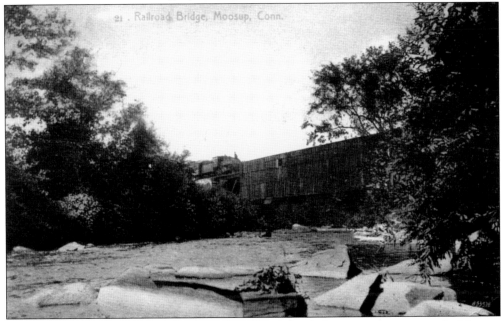

The bridge in this photograph appears to have been the deck truss structure over the Moosup River on the western side of Moosup. The trusses for the bridge were built underneath, with low walls erected above them. (Courtesy of Leroy Roberts Collection, Archives & Special Collections at the Thomas J. Dodd Research Center, University of Connecticut Libraries.)

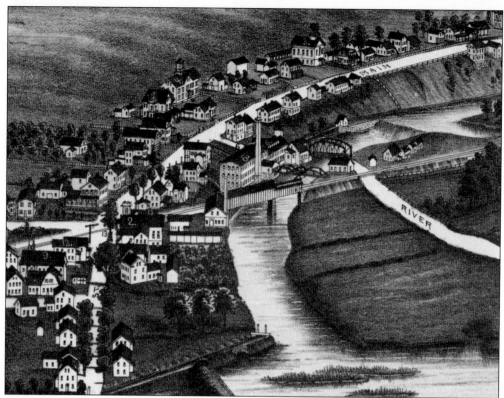

Around 1846, the Providence & Plainfield Railroad built a rail line through the village of Moosup with two crossings of the Moosup River. The eastern bridge, shown here on L.R. Burleigh's 1889 map of Moosup, Uniondale, and Almyville, was a two-span structure with a covered Howe truss span and a pony truss span. (Map reproduction courtesy of the Norman B. Leventhal Map Center at the Boston Public Library.)

In 1901, extensive renovations consisting of new uprights, floor beams, stringers, and floor timbers were made to the bridge over the Moosup River on the east side of Moosup. It was still inadequate for the rail traffic, so it was replaced with a steel span in 1904. At the west side of the village was a span with low sidewalls and the truss underneath. (Courtesy of Richard Roy.)

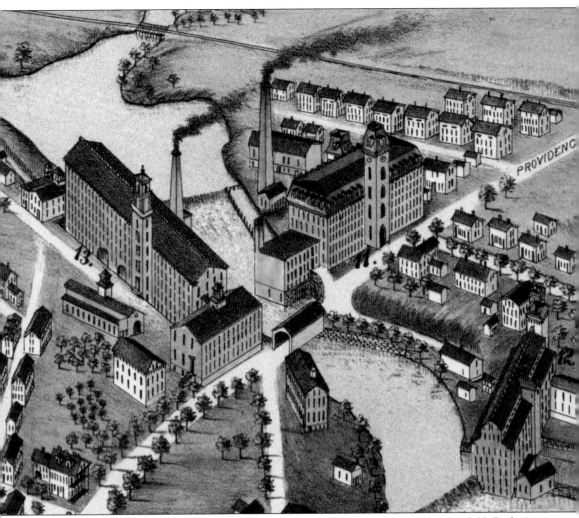

A covered bridge is shown crossing the Quinebaug River on Providence Street on O.H. Bailey's 1877 map of Putnam. Putnam also had a wooden railroad bridge over the Quinebaug. The 1881 *Railroad Commissioners' Report* states that the bridge had been strengthened by the addition of timber arches. A railroad property map from 1888 showed an iron Warren truss deck bridge at that location. (Courtesy of the Map and Geographic Information Center [MAGIC], University of Connecticut Libraries.)

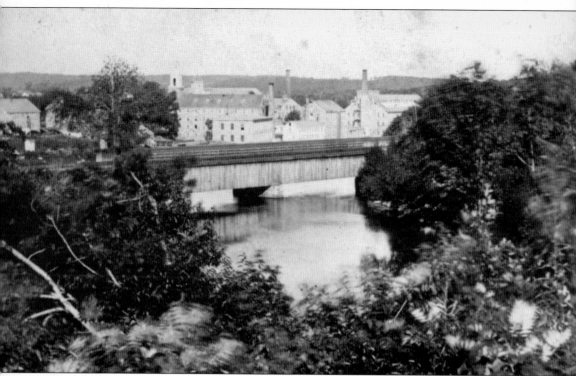

The Central Vermont Railway's deck truss bridge is seen in this view looking downstream along the Willimantic River at Willimantic. The stone buildings in the background were part of the complex of the Willimantic Linen Company, which became the American Thread Company in 1898. Based on the buildings in the background, the photograph was taken sometime between 1864 and 1899, probably in the 1880s or early 1890s when the Willimantic Linen Company was engaged in a major nationwide advertising campaign. Despite its name, the Willimantic Linen Company primarily manufactured cotton thread. (Courtesy of Christine Ellsworth Collection, NSPCB Archives.)

## Seven

# RHODE ISLAND BRIDGES

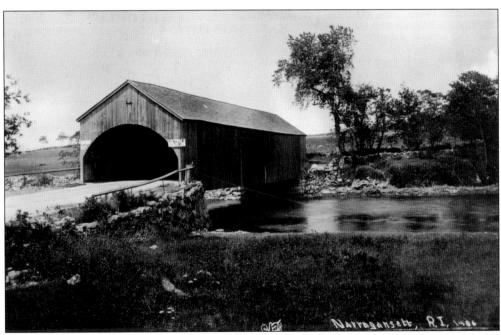

Narragansett Pier had only recently been settled when the Narrow River Bridge was built in 1867. By the 1880s, the village had become a popular summer resort with grand hotels, expensive cottages and a large casino. Situated at the northern edge of the village, the bridge had an interesting rounded portal. It stood at this location until bypassed by the Governor Sprague Bridge in 1920. (Courtesy of Richard Donovan Collection, Bob and Trish Kane.)

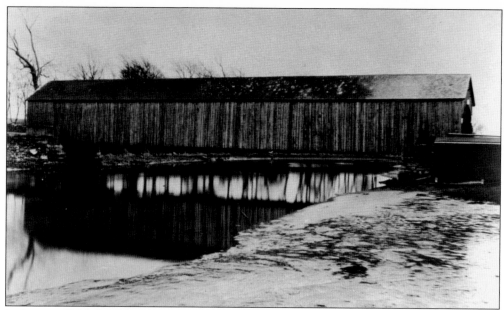

In January 1866, the General Assembly authorized the Town of South Kingstown to construct the Narrow River Bridge at Narragansett Pier. On September 19, 1866, as the bridge neared completion, the construction supports were removed, causing the bridge to collapse. Construction started again, and by late August 1867, the new bridge was ready for travel. (Courtesy of Richard Sanders Allen Collection, NSPCB Archives.)

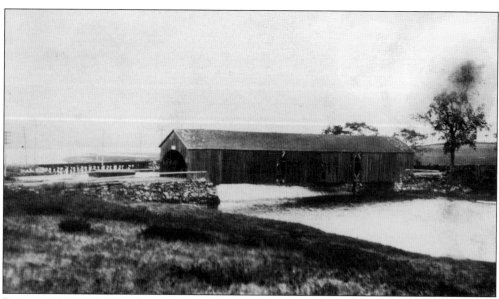

Between 1899 and 1922, the Sea View Railroad operated a streetcar line from East Greenwich to Narragansett Pier. The railroad's bridge over the Narrow River can be seen behind the covered bridge in this photograph from October 1916. (Courtesy of Rhode Island Department of Transportation.)

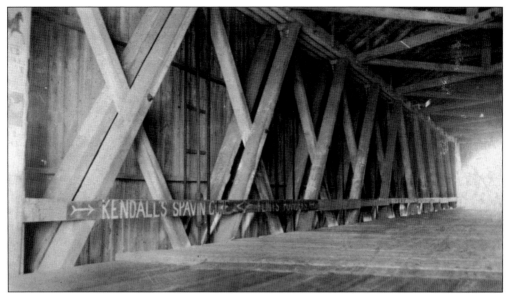

Taken during a bridge inspection on January 14, 1913, this photograph shows the newly replaced floorboards and white-pine Howe truss that supported the Narrow River Bridge at Narragansett Pier. An advertisement for Kendall's Spavin Cure, a liniment for horses and cattle, is painted on the interior boards. Spavin is the swelling of a leg joint that can lead to lameness in an animal. (Courtesy of Rhode Island Department of Transportation.)

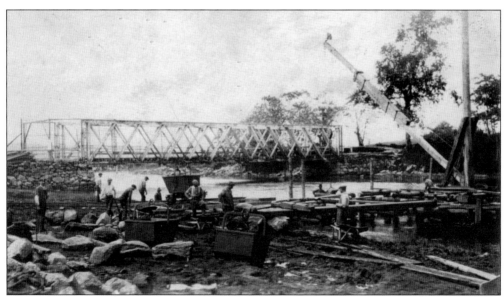

The Narrow River Bridge was dismantled during the summer of 1920. Only the Howe truss skeleton remains in this photograph taken on June 29. The concrete arch Governor Sprague Bridge that replaced it cost $103,599.16 and opened to traffic in September 1921. It was named after William Sprague IV, governor during the Civil War and first president of Narragansett's town council in 1900. Sprague died in 1915. (Courtesy of Rhode Island Department of Transportation.)

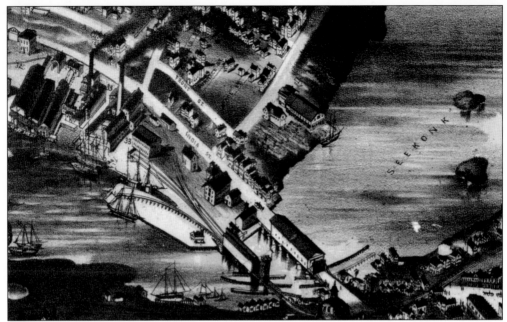

O.H. Bailey's 1882 map of Providence shows the covered highway and railroad bridges over the Seekonk River at India Point, connecting that city with East Providence. At the time of their construction, they were interstate bridges, as East Providence was part of Massachusetts until 1862. In 1867, the draw span of the highway bridge was widened from 24 to 38 feet. (Map reproduction courtesy of the Norman B. Leventhal Map Center at the Boston Public Library.)

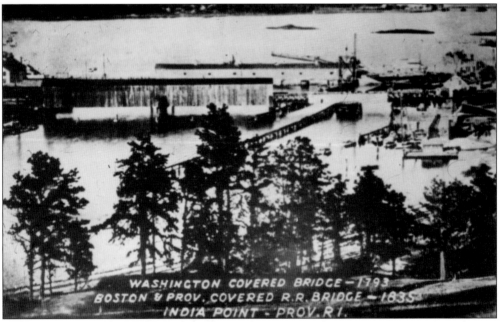

When looking north from Fort Hill in East Providence, the India Point Bridge of the Boston & Providence Railroad is in the foreground, with the Washington Toll Bridge behind it. The text on the photograph incorrectly states that the Washington Bridge was built in 1793. The 1793 bridge was destroyed during the Great September Gale of 1815. (Courtesy of Richard Roy.)

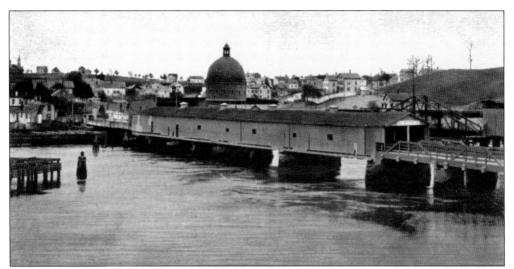

On November 20, 1860, ownership of the Washington Toll Bridge was transferred from the Providence Washington Bridge Society to the City of Providence. It was closed on June 23, 1885, demolished, and replaced with a steel truss bridge. The eastbound lanes of Interstate 195 presently occupy this location. The domed structure in the background is a gasometer, which is a gas storage tank, in East Providence. (Courtesy of Richard Sanders Allen Collection, NSPCB Archives.)

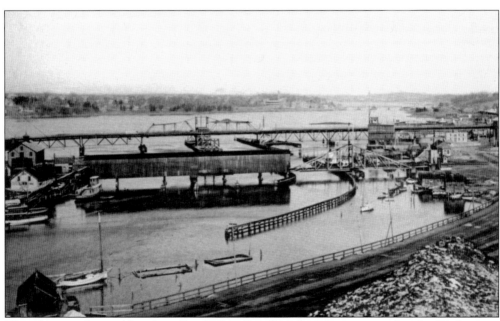

This photograph was taken from Fort Hill in East Providence some time after the Washington Bridge was replaced in 1885. The covered portion of the railroad bridge was replaced in 1901 or 1902. It was the earliest known interstate railroad bridge, having been built in 1835 by Thomas Hassard when East Providence was still part of Massachusetts. The railroad bridge was replaced by another covered bridge after the Civil War. (Courtesy of Edward J. Ozog.)

Since many covered railroad bridges were replaced in the early years of photography and were often located in remote areas, photographic record of their existence is rare. Railroad records will occasionally refer to them as covered bridges or Howe truss bridges, but the term "wooden bridge" is much more common. Fortunately, some have appeared on panoramic maps prepared in the closing decades of the 19th century. For example, O.H. Bailey's 1889 map of Clyde, River Point, and Arctic shows a covered bridge on the Pawtuxet Valley Railroad line in the River Point section of West Warwick. There is no bridge at this location today. The bridge seen up and to the right of the covered bridge is now part of a recreational trail. The annual *Railroad Commissioners' Report* for 1895 noted that a wooden bridge on this line at Clyde was replaced with a new steel deck bridge that was 178 feet long. The railroad bridge at Clyde is beyond the limits of the map. (Map reproduction courtesy of the Norman B. Leventhal Map Center at the Boston Public Library.)

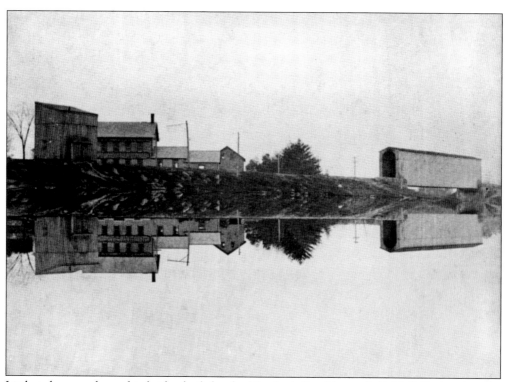

Little is known about this bridge built by the Hartford, Providence & Fishkill Railroad at the village of Anthony in the eastern part of Coventry. The covered bridge crossing the South Branch of the Pawtuxet River is believed to have been a Howe truss built in 1853. It was replaced by the current iron bridge around 1895. (Courtesy of Richard Sanders Allen Collection, NSPCB Archives; William W. Lombard photograph.)

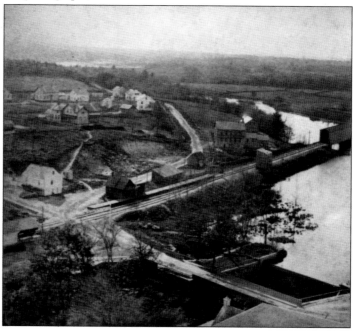

This view of Anthony shows the Mill Pond Dam and Laurel Avenue in the foreground, and the railroad covered bridge is at the center right edge. This line from Coventry to Plainfield, Connecticut, was abandoned in 1967. It is now part of the Washington Secondary Rail Trail. (Courtesy of Robert N. Dennis Collection of Stereoscopic Views, Miriam and Ira D. Wallach Division of Art, Prints and Photographs, The New York Public Library, Astor, Lennox and Tilden Foundations.)

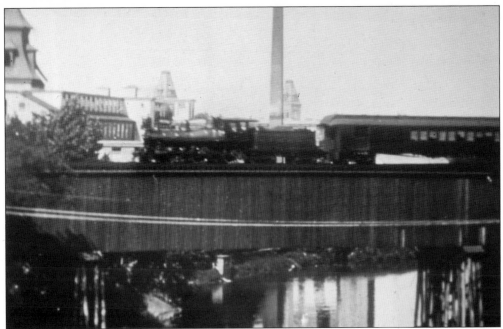

One of the many wooden truss bridges within the city of Woonsocket was a deck truss structure crossing the Blackstone River about 750 feet southeast of the depot. This photograph of a northbound Providence and Worcester passenger train with Clinton Mill in the background was taken by Charles S. Lawton around 1900. (Courtesy of Woonsocket Harris Public Library.)

A 1920 view of the Blackstone River railroad bridge southeast of the depot appears to show a steel bridge at this location. There are two road crossings in the short distance between this bridge and the depot: Main and Clinton Streets. In the 1860s, both roads were crossed by wooden pony truss bridges. (Courtesy of Woonsocket Harris Public Library.)

In 1898, the New Haven Railroad constructed a covered bridge on a spur line over the Blackstone River between Hamlet Village and the Social Mills area of Woonsocket. This crossing was the last historical covered bridge built in Rhode Island. (Courtesy of NSPCB Archives; Richard Sanders Allen photograph.)

The Hamlet Railroad Bridge was a single-span Howe truss, with a pony truss approach span over an old power canal on the Hamlet end and a long trestle approach on the Social Mills end. The interestingly shaped roof covered a pedestrian walkway on the downstream side. (Courtesy of NSPCB Archives; Richard Sanders Allen photograph.)

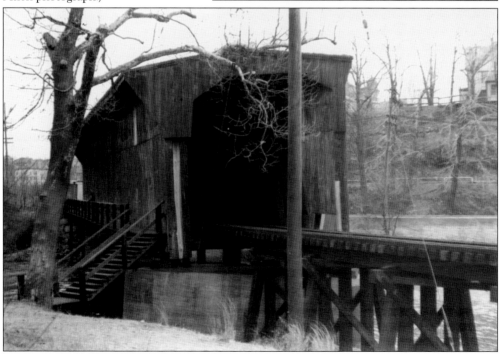

Like many other wooden railroad bridges, the Hamlet Bridge was supported by Howe trusses. In the 1950s, one train a day would pass over it to service the American Wiper-Waste Mill on Social Street. The bridge was more commonly used by pedestrians crossing the Blackstone River on the downstream walkway. (Left, courtesy of Richard Sanders Allen Collection, NSPCB Archives; below, courtesy of Richard Roy.)

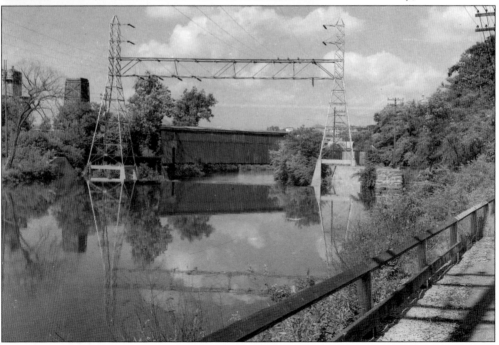

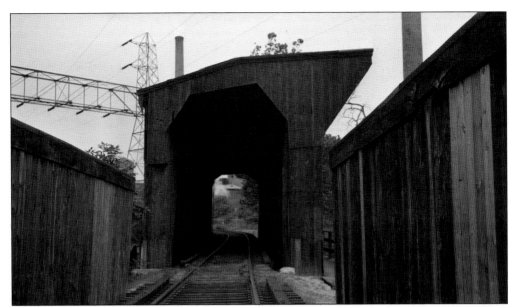

When this photograph was taken in August 1948, the Hamlet Bridge was still in excellent shape and perfectly adequate for the light traffic using it to cross the Blackstone River. However, the era of historical covered bridges in Rhode Island ended on August 19, 1955, when the Hamlet Railroad Bridge was swept away. (Courtesy of NSPCB Archives; Henry Gibson photograph.)

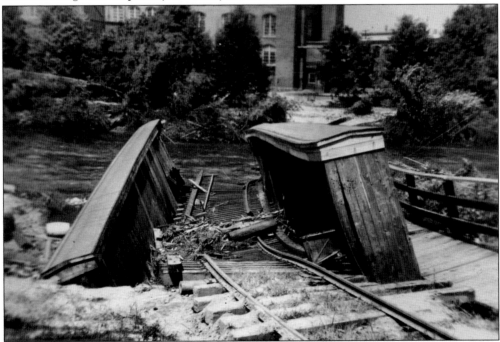

Only the pony truss remained after the Blackstone River swept the Hamlet Bridge off its abutments and carried it downstream. The flood was caused by Hurricane Diane, which dropped nine and a half inches of rain on an area that had already been saturated with heavy rains from Hurricane Connie a week earlier. The resulting floodwaters caused extensive damage throughout Rhode Island and Connecticut. (Courtesy of Woonsocket Harris Public Library.)

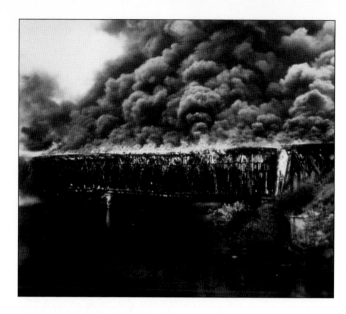

The Bandwagon Bridge crossed the Blackstone River southwest of the intersection of River and High Streets in Woonsocket. It was constructed when the Woonsocket & Pascoag Railroad revived an abandoned rail line between Woonsocket and Harrisville Junction in 1891. The first train over the 438-foot-long Howe truss structure, on February 5, 1891, carried a group of local dignitaries and railroad officials. It was destroyed by a fire on October 22, 1935. (Courtesy of Woonsocket Harris Public Library.)

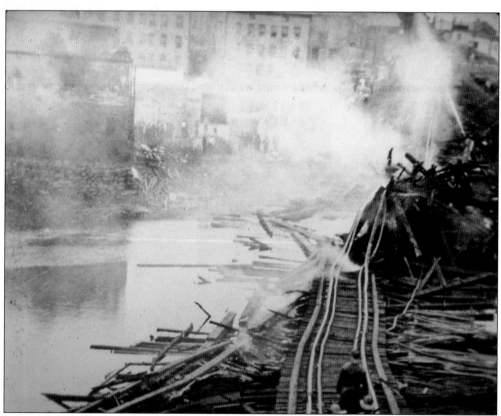

The burning structure of the Bandwagon Bridge collapsed into the river less than half an hour after the fire was discovered. A locomotive and several freight cars were left stranded on the western side of the bridge since the track west to Harrisville had been removed 10 years earlier. (Courtesy of Woonsocket Harris Public Library.)

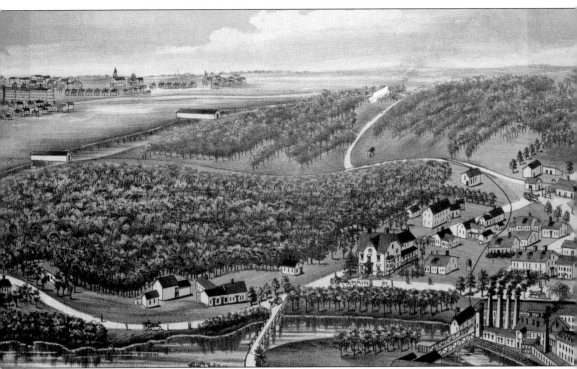

O.H. Bailey's 1889 map of Pontiac, Rhode Island, shows two railroad covered bridges over the Pawtuxet River between Pontiac and Natick. The bridge at the center left was on the Pawtuxet Valley Railroad while the one above it and to the right was on the New York & New England Railroad. Neither of them appears to be the 300-foot-long covered railroad bridge between Natick and Pontiac that burned on August 12, 1900. Smoke was seen coming from the bridge around 6:00 p.m. in the evening. Within minutes, the entire structure was engulfed in flames. Firemen were hindered by the lack of water in the Pawtuxet River. According to a *Pawtuxet Valley Times* article, the river "had been turned off to facilitate the cleaning of the bed of the river." A few minutes later, the burning structure collapsed. (Map reproduction courtesy of the Norman B. Leventhal Map Center at the Boston Public Library.)

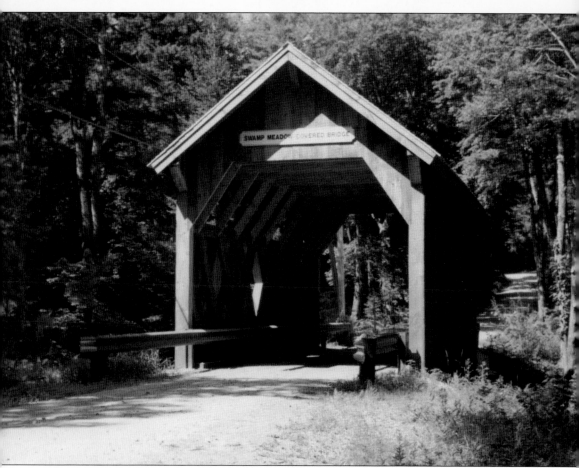

The first Swamp Meadow Covered Bridge in Foster was the result of a six-year-long effort to locate an appropriate site, raise the necessary funds, and gather the volunteers to build the bridge. The bridge included Town lattice trusses constructed over an existing steel bridge on Central Pike. The wood was donated by the Providence Water Supply and transported from its Scituate Reservoir property. When dedicated in December 1992, it became the first wooden covered bridge over a public highway in Rhode Island since the Narrow River Bridge in Narragansett was replaced in 1920. On September 11, 1993, less than a year after the dedication, the bridge was burned down by two young men and a boy from the area. (Author's collection.)

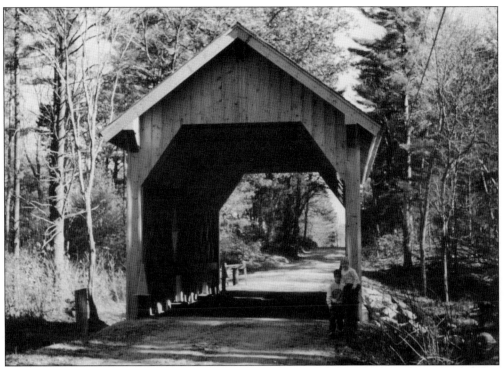

After Foster's covered bridge was burned in September 1993, donations poured in to erect a replacement. Volunteer crews assembled again and constructed the second 40-foot-long Swamp Meadow Covered Bridge over Hemlock Brook. Opening ceremonies were held on November 5, 1994. Although it is constructed over a steel deck, the bridge is otherwise true to Ithiel Town's truss design. (Both, author's collection.)

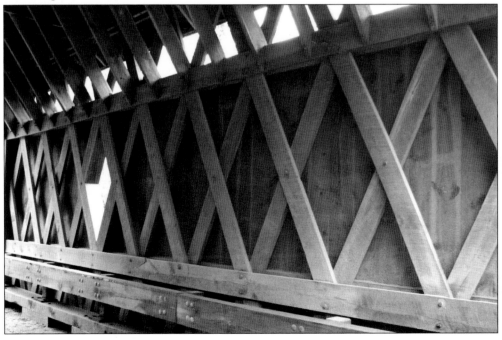

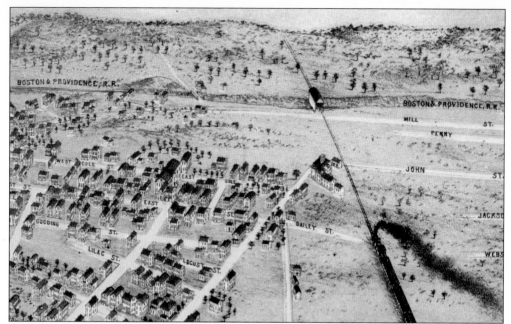

In 1877, O.H. Bailey and J.C. Hazen created a bird's-eye view of Pawtucket and Central Falls that showed this covered bridge on the Providence & Worcester Railroad crossing over the Boston & Providence Railroad in the northern part of Pawtucket at the Massachusetts state line. (Courtesy of Geography and Map Division, Library of Congress.)

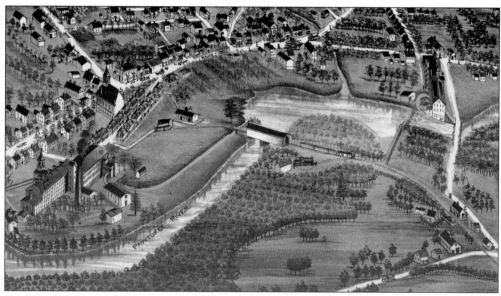

In 1880, the New York, Providence & Boston Railroad built a covered bridge over the Pawtuxet River at the village of Hope near the boundary between Scituate and Coventry. The bridge, shown here on O.H. Bailey's 1889 map of "Hope, Jackson, Fiskville and Arkwright," was replaced in 1924. (Map reproduction courtesy of the Norman B. Leventhal Map Center at the Boston Public Library.)

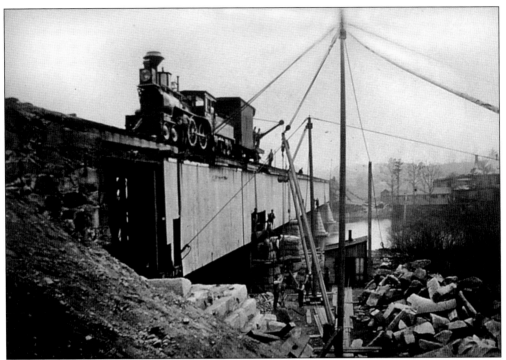

In the mid-1860s, the Boston & Providence Railroad built the Tin Bridge over the Blackstone River between Central Falls and Pawtucket. The name came from the metal sheathing placed under the rails to keep sparks from falling onto the wooden truss below. In 1876, the railroad replaced the original bridge with the five-span, 380-foot-long bridge shown in these photographs. (Courtesy of Edward J. Ozog.)

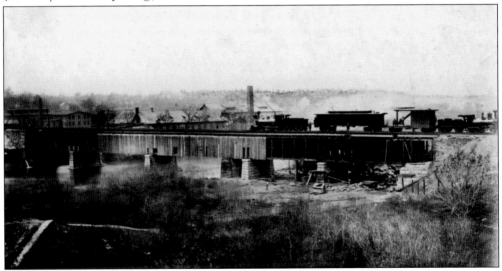

The Tin Bridge was reported to be in perfect condition in 1896 when it was replaced by a steel-plate structure. Even though the first bridge was the only one to use metal sheathing under the rails, the Blackstone River crossing between Central Falls and Pawtucket is still referred to as the Tin Bridge. This photograph was taken from the Central Falls side looking south towards Pawtucket. (Courtesy of Beverly Historical Society and Museum.)